©opyright
WORKFLOW FOR PHOTOGRAPHERS

Protecting, Managing, and
Sharing Digital Images

CHRISTOPHER S. REED

Copyright Workflow for Photographers
Protecting, Managing, and Sharing Digital Images

Christopher S. Reed

Peachpit Press
www.peachpit.com

To report errors, please send a note to errata@peachpit.com
Peachpit Press is a division of Pearson Education.

Copyright © 2015 by Christopher S. Reed

Project Editor: Valerie Witte
Production Editor: Dennis Fitzgerald
Development and Copyeditor: Elizabeth Kuball
Proofreader: Steffi Drewes
Composition: Kim Scott, Bumpy Design
Indexer: Valerie Haynes Perry
Cover Images: Christopher S. Reed, Rock and Wasp (main photo)
Cover Design: Aren Straiger
Interior Design: Mimi Heft, with Kim Scott, Bumpy Design

Notice of Rights

Notice of Liability

Trademarks

ISBN-13: 978-0-133-90405-5
ISBN–10: 0-133-90405-9

9 8 7 6 5 4 3 2 1
Printed and bound in the United States of America

To the talented professionals of the U.S. Copyright Office,
whose commitment to the interests of authors
and creators is a beacon in an otherwise relatively
dark and largely dysfunctional government.

Acknowledgments

First off, many thanks to the entire team at Peachpit Press, without whom this book never would have happened. My sincere thanks to development and copy editor Elizabeth Kuball for converting my sometimes unnecessarily verbose prose into something that's useful and more readable, production editor Dennis Fitzgerald for managing the process that turned my words on a page into a finished book, and project editor Valerie Witte for making sure that everyone involved did what they were supposed to do when they were supposed to do it (including me). Thanks also to proofreader Steffi Drewes; indexer Valerie Haynes Perry; and designers Kim Scott of Bumpy Design, Mimi Heft, and Aren Straiger for making this book look as great as it does.

Although not directly involved with this book, I should also thank John Mosley, the former executive editor of *Planetarian*, the journal of the International Planetarium Society, who published my first article back in 1996, which gave me the thirst for getting my work published. I don't know whether he knew at the time that I was only a sophomore in high school, but if he did, my gratitude runs even deeper.

Many thanks to the talented staff of the U.S. Copyright Office with whom I had the privilege of working for just over three years. There are far too many names to mention here unfortunately, but I owe a particular debt of gratitude to the Register of Copyrights and Director Maria A. Pallante, as well as the rest of the senior leadership: Doug Ament, Jacqueline Charlesworth, David Christopher, Karyn Temple Claggett, Rob Kasunic, Bill Roberts, and Elizabeth Scheffler. As creators, we're very fortunate to have them at the helm of the national copyright system and that they have the ear of Congress when it comes to copyright-related issues. I am very fortunate to have had the opportunity to work with them.

This book was largely inspired by the questions I got at the dozens of talks I've given on copyright issues for photographers, so thank you to all the attendees for your thoughtful questions, and to the organizers of the events at which I spoke. Thank you also to Danita Delimont, Sylvie Fodor, Judy Herrmann, Richard Kelly, Michael Masterson, Gene Mopsik, Cathy Sachs, and Wendy Zieger, as well as the American Society of Media Photographers, the American Society of Picture Professionals, and CEPIC, for all their support of my speaking and writing over the years.

Though writing is a famously solitary endeavor, I was fortunate enough to have a strong group of friends—Brandynn Reaves, Shane Scanlon, Ted Serra, Jesse Solomon, and T.J. Solomon—whose support and encouragement throughout the planning and writing stages of this book was instrumental in getting it across the finish line. As if writing a book weren't stressful enough, I moved across the country from Washington, D.C., to Los Angeles while working on this project to pursue what is more or less my dream job in Hollywood. Despite the challenges inherent in switching jobs and moving to a new city, I was lucky to have Earl Clarkston, Greg Dina, Melissa Kriz, and Travis Pham to throw me headfirst into their respective social pools, which helped make the transition almost seamless.

Finally, I would be remiss if I did not thank my parents, Anne and Andy, whose constant nagging to do my school reading assignments very likely had something to do with me ending up being so interested in writing, and my sisters, Karen and Jennifer, who had to witness my tantrums about doing the aforementioned reading assignments for so many years (and who graciously agreed to appear in the sample image that appears at the end of Chapter 4—I promise the check is in the mail). And of course, I owe a great deal of thanks to my partner, Ryan, who never hesitates to supply his critical but constructive thoughts of my work (and sometimes of me) which serve to make my work stronger and make me a better person. I love you.

Notwithstanding all the help and support of the people listed here, this book is fundamentally my own work, and all errors, omissions, and the like are mine alone.

About the Author

Chris Reed is both a lawyer and a photographer. On the legal front, Chris specializes in copyright and media law; photographically, he focuses largely on landscape and travel photography.

Photo by Ryan R. Kennedy

Chris recently served as senior advisor for policy and special projects at the U.S. Copyright Office, where he advised the register of copyrights on a variety of issues relating to copyright law and policy. He was involved in several of the register's landmark speeches and publications, including *The Next Great Copyright Act* and *The Next Generation Copyright Office: What It Means and Why It Matters*, as well as testimony presented before Congress. Prior to joining the Copyright Office, Chris was an attorney with the Antitrust Division of the U.S. Department of Justice, where he worked principally on matters relating to the entertainment and media industries. Notably, he participated in the United States' investigation of the proposed Google Book Search Settlement Agreement and the investigation of the Comcast and NBC-Universal merger.

Chris received his B.S. in economics from Lehigh University and holds a J.D. and LL.M. in intellectual property from the University of New Hampshire School of Law, where he served as editor-in-chief of *IDEA: The Intellectual Property Law Review*, and where he currently serves as an adjunct professor teaching an advanced copyright course as part of the school's intellectual property master class curriculum. After graduation, Chris served as a law clerk to the Honorable Steven J. McAuliffe, Chief Judge of the U.S. District Court for the District of New Hampshire.

Chris is a member of the American Bar Association, the American Society of Media Photographers, and the Copyright Society of the United States. He is a member and fellow of the International Planetarium Society and also serves on the Board of Trustees of the American Society of Picture Professionals.

His photography website is www.chrisreedphoto.com and his personal website is www.csreed.com.

Chris currently resides in Los Angeles.

Contents

Chapter 5 After Applying for Registration 90

Chapter 6 Sharing, Selling, and Licensing Images 106

Image Credits

Cover

Primary image, *Shutterstock file no. 167389643, © 2011 Rock and Wasp*; *Good Morning Washington*, © 2013; *EMP Museum II*, © 2011; *Point Reyes Lighthouse*, © 2013; *Heartland*, © 2011; *Royal Palm Sunset*, © 2011; *Barcelona Architecture*, © 2013; *Fast Forward*, © 2013; *Japanese Tea House*, © 2013; *Hagia Sophia*, © 2011; *Cherry Blossoms*, © 2012; *Seattle*, © 2011; *Blackwater Canyon*, © 2012.

Table of Contents

Capitol Sunrise, © 2013.

Introduction

Chapter opener: *Sunset on the National Mall*, © 2013.

Chapter 1

Chapter opener: *Blackwater Canyon*, © 2012.

Chapter 2

Chapter opener and Figure 2.3: *Good Morning Washington*, © 2013.

Chapter 3

Chapter opener: *Seattle*, © 2011.

Figure 3.19: Miscellaneous images within screenshot, © 2012.

Chapter 4

Chapter opener: *Point Reyes Lighthouse*, © 2013.
Figure 4.24: Untitled, © 2014.

Chapter 5

Chapter opener: *Heartland*, © 2011.

Chapter 6

Chapter opener: *Cle Elum River*, © 2011.
Figure 6.2: *Snowshoe Sunset*, © 2013.

Chapter 7

Chapter opener: *Solitude*, © 2011.

Chapter 8

Chapter opener: *Japansese Tea House*, © 2013.
Figure 8.1: Shutterstock file no. 139488335, © seamuss. Used under license. Icons courtesy of IcoMoon, www.icomoon.io. Used under a Creative Commons Attribution 3.0 license.
Figures 8.2–8.4: Shutterstock file no. 93946417, © John T. Takai. Used under license.
Figure 8.5: Flowchart created with Lucidchart, www.lucidchart.com.

Introduction

Welcome to *Copyright Workflow for Photographers*! This book is part legal manual and part software manual. The legal portion is designed to help you understand the basics of copyright law and how it pertains to your daily life as a photographer, while the software portion will help you build sensible copyright and rights-management concepts into your existing workflow. Before I get started, though, I want to describe the landscape of the copyright community and, more specifically, the photographer's place within it.

The Plight of the Digital Photographer

In general terms, copyright law provides to creators—including photographers—the right to exclusively control and, thus, profit from their works for a fixed period of time. In the olden days, it was relatively difficult to infringe on a photographer's work on any significant scale. You had to get access to the physical copy of the image—either the negative or the transparency—which usually required interacting with the photographer directly or with the photographer's agent; then you had to make physical copies in a darkroom. Put simply, infringement of a photograph used to require a reasonable investment in terms of time, equipment, and technical skill.

Fast-forward to today. The Internet has become a primary mechanism for the marketing and distribution of images. Families share photos among relatives on commercial websites such as Flickr, and virtually every professional photographer has a website where his or her images are available for the entire world. Making copies of those images is typically as easy as right-clicking it and telling your computer where to save the file.

The relative ease with which people can remove and manipulate content has created a widespread infringement problem for many creative professionals. The music industry famously did battle with peer-to-peer file sharers who transferred digital copies of music with impunity, and other creative businesses such as the motion picture and publishing industries experience similar problems.

For photographers, the issues are particularly pronounced, however, because of the rich visual culture in which we live and the meteoric rise of web-based platforms that enable photo sharing. Because visual content has become so ubiquitous, many web users don't think twice about uploading content they found from some other website—yet, technically, it amounts to infringement in most cases. With the right-click of a mouse, a user can make a reproduction of a copyrighted image and, with a few more clicks, upload that same image to his or her own social media profile, prompting a flurry of "likes" or "shares" that further disseminate the image without permission of the original photographer. Meanwhile, the companies that operate these platforms often benefit financially by selling advertising.

Indeed, as Eugene Mopsik, the executive director of the American Society of Media Photographers (ASMP) has quipped on numerous occasions, it often appears that everyone has figured out how to make money from photography, except for the photographers.

The Paradox of "Getting It Out There"

Among aspiring professional photographers, and even those who don't intend to profit from their work, it has become a mantra that to be successful (however you might define that term), you have to "get your work out there." You do so by uploading it to social networking sites, blogs, personal websites, and photo sharing sites. Sharing images has never been easier or cheaper, which has enriched the experience of photography for hobbyists and professionals alike and, perhaps most important, created a new sense of community among those with a passion for photography.

On the commercial side, marketing, distributing, and licensing photography has never been easier, at least from a technical perspective, as faster connection speeds and a proliferation of platforms on which to license works have brought image buyers and sellers closer together. (Of course, the business of marketing photography has become substantially more difficult than it once was because of increased competition and market fragmentation, which has resulted in downward price pressure on the industry.)

The necessary implication of "getting it out there" is making it available for others to infringe upon—whether intentionally or unintentionally. A recent post from a participant on a photography-related web forum summed it up nicely: "My quandry is between having Internet exposure to a broad audience and protecting my copyrights."

Copyright's Perception Problem

One of the biggest challenges facing the copyright system today is the broad public misunderstanding of copyright law. Too often, the public discourse surrounding copyright law gets characterized in terms of big content companies—film studios, recording companies, publishers, and the like—wanting to preserve their antiquated business models by bringing infringement litigation against those who find new, innovative ways to distribute or use copyrighted content. Many people even believe that copyright enforcement has led to a decline in technological innovation.

The reality is exactly the opposite. Without copyright law, those companies would have little incentive to invest in creating the content in the first place, let alone innovating new distribution technologies or business models. But more important, what's often missing from the copyright discussion is the role of the individual creators—the people who actually put in

the work to create the books, music, films, and the like that comprise our cultural heritage.

For photographers, the problem is even more significant because photographers, more often than not, work independently and have nothing but their images—and more specifically the copyright interest in those images—from which to generate a living. Those who don't generate income from their images still often avail themselves of the exclusive control that copyright provides in terms of deciding when and where to share their images. (And of course, those who don't want to are free to disavow their rights by committing the work to the public domain.)

Even among those who do understand copyright law, there is increasingly little respect for it. The anonymity of the Internet has only advanced the erroneous perception that copyright infringement is victimless, or that simple online uses such as social media posts, should not require permission of the copyright owner, because it provides the creator with more exposure than he or she otherwise would have received. Such arguments ignore the fundamental principles of copyright, which include the right to control the use of the work, subject to certain exceptions (such as fair use, described in Chapter 1).

The point is that when copyright comes up in general social circles, it's often met with hostility, which can be a challenge for photographers whose livelihoods depend on it. Grassroots organizations such as the Copyright Alliance (www.copyrightalliance.org) and Creative Future (www.creativefuture.org) are working to give independent creators a voice. Through recently improved public outreach initiatives, the Copyright Office is working hard to improve the public perception of the copyright system, but until the law is updated to accommodate the digital environment, and until it becomes more accessible to the public, the perception problem is one that we as independent creators and copyright owners must be aware of.

Specific Challenges for Photographers

Copyright law is outdated and, in some cases, it isn't effectively serving the needs of the creative community. In this section, I provide some specific examples of how copyright law is presenting challenges that impact photographers specifically.

Lack of effective enforcement tools

Copyright infringement of images is rampant on the Internet. The ease with which images can be freely downloaded, copied, and re-uploaded or used in new types of digital content, coupled with a general sense among many Internet users that if something appears online, it's free for the taking, has led to a widespread infringement problem for photographers.

Under the Digital Millennium Copyright Act, copyright owners are entitled to issue "takedown notices" to service providers (such as social networking sites) to demand that the infringing content be removed from their service. (I discuss takedown notices in more detail in Chapter 7.) That approach seems promising in theory, but in practice it's largely ineffective because the takedown notice procedure applies only to a specific instance of infringing content. If a particular image is removed from a social networking site, the user may simply re-upload it, requiring the photographer to issue yet another takedown notice. To many in the copyright community, this has become known as the "whack-a-mole" problem.

Some service providers have implemented blocking technologies that identify previously removed content and prevent users from re-uploading it, and some will suspend or terminate the accounts of users caught engaging in such behavior. Still, the responsibility of Internet intermediaries to police their users' infringements remains a very hotly contested issue between the copyright community and the technology community. Until Congress or the courts provide some clarity, it's unlikely that the process will get much easier for photographers.

Depending on the nature of an infringement and the losses that result, a photographer might want to sue the alleged infringer in court. That, too, may seem like a good idea in theory, but the reality is that the cost to bring a lawsuit in federal court (copyright law is exclusively federal; see Chapter 1 for more on this) often far exceeds the likely recovery associated with a particular infringement, particularly in light of the declining value of individual image licensing in the marketplace. (Although there is no requirement that a court consider reasonable license fees when it's determining an appropriate damages award, such fees are very often where courts begin their analyses.)

The Copyright Office recently studied the issue and issued a report encouraging Congress to consider developing a small claims tribunal within the Copyright Office to accommodate authors who want to sue for relatively small amounts of money. Although such a system is very likely many years away, the fact that the Copyright Office is evaluating the possibility is an encouraging step forward. You can read the Copyright Office's report and proposal at www.copyright.gov/docs/smallclaims.

An outdated registration system

Copyright registration is effectively a bargain with the public: in exchange for the ability to receive enhanced damages, copyright owners agree to provide the public with certain information about the copyrighted works they've created. You can read more on this in Chapters 1 and 2.

The registration system (covered in detail in Chapters 3 and 4) benefits both sides of the copyright equation: by effectively putting the public on notice of a particular copyright claim, and by providing would-be users of copyrighted works with a source of contact information for rightsholders.

The system works quite well if you happen to know the title or author of the work that you're searching for. But for photographers or image users, the current system presents significant challenges. Most photographers don't give individual titles to their works, for example. And even when they do, very often they use the camera's native filenames, which provide very

little guidance to users about the nature of the underlying work. In short, because the current registration system doesn't supply image thumbnails or allow for reverse image searching, it's of limited practical value to the photography community beyond the legal entitlements that registration provides.

Several years ago, the director of the Copyright Office launched a comprehensive evaluation of the office's information technology systems with the goal of developing a framework for a next-generation registration system. In its public notice announcing the study, it specifically noted the need for improving the system for photographers, including the possible development of image-based technologies. The development of a new system is likely a number of years away, but the good news is that because the Copyright Office has broad legal authority to manage the registration system, such improvements may not require Congress to intervene.

The Digital Reality

The reality of the digital age is perhaps best characterized by the proverbial double-edged sword. On the one hand, the ease with which digital images are created, shared, and distributed offers photographers—professionals and amateurs alike—with more opportunity than ever before to expose the world to their work; on the other hand, that work is now more easily stolen or otherwise misappropriated, and photographers can very quickly lose control.

Assuming that keeping your work locked away on private hard drives is not an option, you need to develop copyright management and content protection strategies that fit within your existing workflow that will help you optimize the balance between maximizing exposure and maintaining control of your work. Developing those strategies is the focus of this book.

Copyright Basics

Before you try to understand how to protect your digital images and incorporate key copyright concepts into your daily workflow, you need to have some basic knowledge of the fundamental principles of copyright. In this chapter, I explain the basic structure and vocabulary of copyright law.

A Very Brief History of Copyright Law

The concept of copyright law first arose in Great Britain in 1710, when the Statute of Anne provided that authors of books had the exclusive right to print those books. In the United States, copyright law has its origins in one of the founding documents of the nation, the Constitution, which provides Congress with the authority to "promote the progress of science and the useful arts, by securing for limited times to authors and inventors the exclusive right to their respective writings and discoveries."

In short, the founders believed that the public interest would be enriched by providing an economic incentive—a period of exclusivity for limited times—for creators to create new works. After the period of exclusivity concluded, the works would become part of the public domain.

The nation's first federal Copyright Act was enacted in 1790. Since then, Congress has undertaken comprehensive updates of the copyright law, the most recent of which took place in 1976. That law, which became effective on January 1, 1978, has been updated on several occasions (notably, in 1998, with the passage of the Digital Millennium Copyright Act), but otherwise the law remains largely as it was when it was first enacted. The outdatedness of current copyright law has been the subject of recent congressional action and various studies and public statements of the U.S. Copyright Office, which is the principal advisor to Congress on copyright-related issues (more on that in Chapter 2).

Photography wasn't covered by copyright law until 1865, and motion pictures weren't covered as a separate category until 1912. (Prior to that, motion pictures were considered protected as a series of still images.) Today, photography and other forms of visual art enjoy their own specifically articulated category in the law: "pictorial, graphic, and sculptural works."

What Copyright Protects

Fundamentally, copyright protects "original works of authorship" that are "fixed in any tangible medium of expression." So, the two fundamental prerequisites for copyright protection are: *original authorship* and *fixation*.

In the copyright context, *originality* does not necessarily mean that a particular work is unique or one of a kind. It simply means that the original is the product of the author's own mind and that it wasn't copied. So, if the authors of two very similar copyrightable works can demonstrate that they independently created their works, without having copied or otherwise borrowed from each other, then under copyright law, each author is entitled to a separate copyright.

> **Note**
>
> Even though you might not think of yourself as an "author," when it comes to copyright language, that's the term that's used—whether you're an author or a photographer or a filmmaker or an artist.

Fixation simply means that the work exists in some medium from which it can be perceived, even if the fixation requires some sort of equipment or device in order to perceive the work. For example, a motion picture on a DVD is said to be "fixed" even though you can't perceive the motion picture without the aid of a DVD player.

Finding the copyright law

The copyright law of the United States is contained in Title 17 of the U.S. Code, which is available on the Copyright Office's website at www.copyright.gov/title17. If you're looking to buy a printed version, visit the Government Printing Office (GPO) at http://bookstore.gpo.gov.

In addition to the law itself, the Copyright Office has issued a number of regulations that govern its operations and procedures. Those regulations can be found in Title 47 of the Code of Federal Regulations, which is also on the Copyright Office website, at www.copyright.gov/title37. The GPO also sells the regulations through its online bookstore.

Finally, the Copyright Office recently released a new version of its *Compendium of Copyright Office Practices,* which describes, often in great detail, the practices and procedures relating to the office's public services, including the registration process. Because the document is intended to be updated regularly, as policies evolve, it's available online, at www.copyright.gov/comp3.

I quote and reference the relevant laws, regulations, and procedures throughout this book, but if you have questions or want more information, these sources are a great place to start.

The copyright law defines eight specific types of copyrightable works:

- Literary works
- Musical works, including any accompanying words
- Dramatic works, including any accompanying music
- Pantomimes and choreographic works
- Pictorial, graphic, and sculptural works
- Motion pictures and other audiovisual works
- Sound recordings
- Architectural works

Copyright does not protect names, titles, short phrases, formats, layouts, blank forms, typography (though font software—the OpenType, TrueType, or PostScript files, for example—is typically protected by copyright), ideas, principles, methods, or systems, though the *expression* of such things may be. For example, this book sets forth a method or system for incorporating copyright principles into your day-to-day workflow; although the system itself is not copyrightable, the book that describes that system is.

Copyright protection arises automatically upon the creation of a copyrightable work. That is, as soon as an original work of authorship is fixed in a tangible medium of expression, the author has a copyright interest in that work. The copyright owner doesn't need to file anything with the government or take any other affirmative steps to secure his or her copyright. The law does provide for copyright *registration,* which affords the copyright owner certain additional rights (described more fully later in this chapter).

Who Owns the Copyright

In most cases, the author of a particular copyrighted work is also its copyright owner, unless the work was made for hire. The author can *transfer* the copyright to another person or entity, as long as the transfer is made in writing. The author can also *license* certain rights, which authorizes another person or entity to use the copyrighted work in a certain way but does not transfer ownership of the copyright.

The distinction between transferring (or "selling") a copyright and licensing it is a topic of frequent debate in the photography community. I cover it in more detail later in this chapter.

Work made for hire is an often misunderstood concept in copyright law. It means that a work was either

- Created by an employee within the scope of his or her employment.

- Created by an independent contractor, but only if the work is one of the several types of works described in the copyright law. These works include contributions to collective works, works intended to be made a part of a motion picture or other audiovisual work, translations, and several other very specific types of works.

So, if a particular work (and the circumstances surrounding its creation) does not fall into one of those two categories, it isn't really a work made for hire, no matter what the parties say or agree to. A person can still *transfer* his or her copyright to someone else, but that doesn't make it a work made for hire.

Selling versus licensing your images

You've probably heard people in the photographic community talk about how you should never "sell your images" or, more specifically, "sell your copyright"; instead, you should license your images. This is because, when you license an image, you retain the right to license it to other people, for other uses, down the road, which means the image can continue to earn you income long after you first created it.

Licenses have lots of different parameters, including exclusivity, duration, scope of use, and the like. The mechanics of drafting licenses is a topic for another book. For now, just know that, under a license, you typically retain the right to make money from the image for the life of the copyright, whereas when you sell (transfer) the copyright to an image, you lose that right and all other rights associated with that image (including, most notably, the ability to put that image in your portfolio, unless you get permission from the buyer).

Whether selling or licensing is most appropriate depends on a number of factors, but it really boils down to a relatively simple business decision: are you going to make more over the life of the image by licensing it over and over again, or can you make more by selling it in one shot, presumably for a much higher price?

Of course, beyond money, you should also consider the control element. If you sell an image copyright outright, you lose the right to control it, which, to some photographers, may be more valuable than the revenue opportunities associated with that image.

Why does work made for hire matter so much? Because if a work is made for hire, it means that the employer owns the copyright from the very beginning—the individual author never owned the copyright. But if the copyright was *transferred* from the author to a subsequent owner, copyright law permits that transfer to be terminated—essentially undone—35 years later. The law of copyright termination is extraordinarily technical, and a detailed discussion about it is beyond the scope of this book, but it's important to recognize how characterizing your copyright ownership interest today can impact your rights in the future.

Because most photographers work for clients under some contractual arrangement (that is, they aren't employees of the client), and because the works typically don't fall into the categories specifically enumerated by copyright law, the copyright of the images is retained by the photographer, and the client must have an appropriate license to use those images.

How Long Copyright Protection Lasts

For works created on or after January 1, 1978, copyright lasts for the life of the author plus an additional 70 years. Like other types of property, copyrights can be granted by will upon the death of the copyright owner, so copyrights of particular works can serve to benefit the author's heirs for up to 70 years. In the case of *joint works* (those prepared by more than one author), the copyright lasts for 70 years beyond the death of the last surviving author.

For anonymous or pseudonymous works, or works made for hire, the copyright lasts for 95 years from the year of first publication or 120 years from the year of the work's creation, whichever expires first.

Determining the copyright status of older work can be a complex undertaking, thanks to various amendments to the copyright law that have extended the length of copyright, in some cases, retroactively. Although a detailed discussion of those rules is beyond the scope of this book, it's worth noting that if you need to figure out whether an older work is still under copyright, you should contact an experienced copyright lawyer.

The "Bundle of Rights" Copyright Provides

The word *copyright* is actually something of a misnomer because within a particular copyright, there exist a number of different rights, which may be divided separately. More specifically, copyright provides the owner the exclusive right to

- Reproduce the work

- Prepare derivatives of the work

- Distribute copies of the work

- Perform the work publicly (in the case of literary, musical, dramatic, or choreographic works; pantomimes; motion pictures; or audiovisual works)

- Display the work publicly (in the case of literary, musical, dramatic, or choreographic works; pantomimes; and pictorial, graphical, or sculptural works)

In addition to this bundle of rights, copyright is territorial, which means rights are specific to each legal jurisdiction. Most countries are members of several international copyright agreements, which effectively harmonize key principles of copyright law. So, rights that exist in one country typically also exist in other countries, but they can be treated separately, meaning copyright owners can license different rights in different countries, often to different parties. Motion picture companies, for example, often license one theatrical distributor in the United States, another in Europe, another in Asia, and so on.

The rights of copyright can be almost infinitely divided into various components, so they can be licensed separately. Indeed, most traditional rights-managed photography licenses do just that: a photographer might license a particular image for use only in the United States, in a particular publication, up to a particular number of copies, and/or for a particular period of time. In the book industry, often a publisher has the exclusive right to distribute printed copies of a particular title within certain territories, while other publishers buy the rights for foreign territories; the right to create an audiobook version of the title is often separately licensed, as are the rights to develop a movie version.

Copyright Limitations and Exceptions

Although copyright law provides certain exclusive rights to authors, it also places a number of limitations on those rights. In this section, I walk you through several of those limitations and exceptions.

Ideas versus expression

Copyright law protects only the *expression* of particular ideas, but not the ideas themselves. That's why multiple photographers can make nearly identical images of the same subject matter without infringing on each other's copyrights. A particular image is protected, but the *idea* embodied in that image is not.

Of course, the line between the idea and the expression can sometimes be a little fuzzy. There have been cases where photographers have been found liable for infringing on other photographers' work without actually copying it. But generally, the underlying idea or concept of an image (or any copyrightable work) is not itself protected by copyright.

First sale

The doctrine of first sale says that the *copyrightable work* is distinct from any particular *copy* of that work. The most common example of the doctrine of first sale is the used-book market. Although the author or publisher of a book has the exclusive right to make copies of that book, once a particular copy of that book has been lawfully transferred to someone else (sold, given as a gift, and so on), that person is free to do with that copy whatever he likes, as long as he doesn't violate any of the exclusive rights of copyright (for example, make a copy of it, publicly perform it, and the like).

In the photography context, that means that when a photographer sells a print of an image, he has no control over the print after the initial sale. The purchaser is free to resell the image, give it as a gift, and so forth. Of course, the buyer is not permitted to make copies of the image embodied in the print, prepare derivatives of the image, and the like.

Digital first sale?

There is currently a debate among copyright experts about whether the concept of first sale applies in the digital environment. The traditional thinking about first sale doesn't really apply in the digital world because the line between the copyrightable work and the physical copy of the work is much less clear. There is, essentially, no way to transfer a copy of, for example, a digital image file, without also making a copy of it, which infringes on the rights of the copyright owner if done without his permission.

Consumer advocates assert that first sale concepts apply equally in the digital age, while content creators typically assert that the first sale doctrine in the digital space threatens to harm their developing digital business models. Eventually, Congress will need to consider the issue.

Fair use

Fair use was originally a court-made doctrine that was folded into the Copyright Act when it was revised in 1976. In short, fair use was intended to be a safety valve of sorts, to ensure that copyright didn't negatively impact other people's rights to free speech.

In essence, the doctrine of fair use permits people to use copyrighted works, without permission of the copyright owner, in very limited ways, to comment upon or criticize the underlying work, in a way that would not have a negative impact on the market for the original.

The four factors that a court must consider in determining whether a particular use is fair are the following:

- The purpose and character of the use, including whether such use is of a commercial nature or is for nonprofit educational purposes

- The nature of the copyrighted work

- The amount and substantiality of the portion used in relation to the copyrighted work as a whole

- The effect of the use upon the potential market for or value of the copyrighted work

Because fair use is highly dependent on the facts of each case, determining whether a particular use is fair unfortunately means that it's difficult to precisely describe what is and is not fair use in advance of a particular dispute. On the one hand, that makes fair use flexible and adaptable. On the other, it makes fair use ambiguous, which can be frustrating to would-be users of copyrighted works.

Although the doctrine of fair use has noble and legitimate policy underpinnings, it has been used with increasing frequency in recent years, particularly in cases where the other exceptions and limitations don't accommodate digital works or uses. The result is a significant broadening of fair use and an increase in the number of unlicensed uses that are permitted by law. In the Introduction, I discuss more fully the general outdatedness of copyright law and the unfortunate impact that is having on the creative community in general and photographers in particular.

Statutory limitations and exceptions

In addition to the fundamental limitations on copyright law described in the previous sections, the Copyright Act contains a number of statutory provisions that limit the rights of copyright owners in specific, narrow circumstances. Basically, Congress has determined that there is a public policy purpose that justifies the abridgment of the copyright owner's exclusive rights in these circumstances.

These circumstances include, for example:

- An exception in favor of libraries and archives so that they may preserve copyrightable works for historic purposes

- Exceptions for individuals who are blind or visually impaired to make reproductions of certain literary works in special formats so that they may be perceived using assistive technologies (such as screen readers)

- A number of statutory licenses, where Congress essentially mandates the licensing of certain works, for certain uses, subject to a government-regulated rate-setting mechanism

What Happens When a Copyright Is Infringed

Copyright infringement occurs when someone exploits one or more of the exclusive rights under copyright without permission of the copyright owner, and where there isn't an appropriate limitation or exception. Infringement can range from blatant wholesale copying to more nuanced infringement, such as using pieces of a copyrighted work in another work as in appropriation art. In determining whether a particular work infringes another work, courts consider whether the works are "substantially similar" to one another.

Infringement is typically a civil matter, which means that it's up to the owner of an infringed copyright to sue the alleged infringer to enforce his or her copyright. To bring a claim for infringement, a copyright owner must first have registered the copyright he or she seeks to enforce (see the next section). If the defendant is found liable, the plaintiff may recover its actual damages and any lost profits associated with the infringement. In the United States, copyright cases are always heard in federal court.

But those damages or lost profits can be difficult to prove, so the law also provides that if the infringed work was registered *either* within three months of publication *or* before the infringement over which the owner is suing, the owner is entitled to recover *statutory damages*, which range between $750 and $30,000 per work infringed (and up to $150,000 per work infringed if the court finds the infringement to be willful). Under statutory damages, the prevailing party may also recover costs associated with bringing the litigation, as well as attorneys' fees, at the court's discretion. Collectively, statutory damages, costs, and attorneys' fees are sometimes referred to as "enhanced damages."

In certain limited circumstances, where infringement is willful and motivated by a commercial purpose, copyright infringement can be pursued as a criminal matter and can result in significant fines and prison sentences for infringers. Criminal treatment of copyright infringement is typically reserved for the most egregious of cases, such as operators of websites that traffic exclusively in infringing goods or other large commercial purposes that engage in nothing more than blatant infringement of films, music, and the like.

The Purpose of Copyright Registration

Although copyright registration is not required to receive copyright protection, it is required before you can file a lawsuit for infringement. In addition, to qualify for statutory damages, and to be able to recover costs and attorneys' fees, you must register your copyright either before the particular infringement occurs *or* within three months of publication of the work that was allegedly infringed.

The goal of registration is to create a public record of ownership for the copyrighted work, so that members of the public can, in theory, find the owner of the work. In effect, registration places the public on notice that a particular owner is claiming the copyright interest in a particular work.

Orphan works

Over the past few years, there has been a lot of talk in copyright circles about issues relating to so-called "orphan works," which, as described by the Copyright Office, refer to "the situation where the owner of a copyrighted work cannot be identified or located by someone who wishes to make use of the work in a manner that requires permission of the copyright owner." In these circumstances, would-be users of copyrighted works are often dissuaded from doing so for fear of severe statutory damage awards. The problem has become particularly pronounced in recent years because the term of copyright protection is so long (and has been retroactively extended in some cases), and sometimes copyright owners don't even realize they own the rights to something created decades ago, let alone care about licensing it.

Congress attempted to legislate a solution in 2008; the bill made it through the Senate, but it never cleared the House. The 2008 proposal would have required that prospective users of orphan works conduct a "reasonably diligent search" to find the copyright owner before undertaking a particular use. If, after conducting such a search, the prospective user still couldn't find the owner, he or she would've been entitled to reduced risk exposure—instead of potentially facing a statutory damages judgment if the copyright owner were to come forward, the damages would've been limited to the value of a reasonable license fee had the user and the owner been able to negotiate from the beginning. Contrary to much of the press surrounding orphan works, it would not have provided users with carte blanche to use copyrighted works without permission or payment.

As of this writing, there is no pending legislation, but both Congress and the Copyright Office have recently opened inquiries into whether the time has come to consider trying again.

The proposed solutions to orphan works present unique challenges to photographers and other visual artists—their works are the ones that are most likely to be orphaned, because there is typically no identifying information about the copyright owner on the face of an image itself. The problem persists in the digital space as well, where copyright-related metadata can be very easily stripped from image files. Registration is one way to help ensure that images don't become orphaned (although, for reasons discussed more fully in Chapters 2 and 3, the current registration system is not particularly hospitable to photographers because of its reliance on text-based searching, as opposed to image recognition and related technologies).

So, registration is essentially a bargain between the copyright owner and the public: in exchange for providing public information about the scope of the copyright claim and the identity of the copyright owner, the law provides additional protections, in the form of the availability of enhanced damages (see the preceding section for more on enhanced damages). Beyond such damages, the public record also makes it possible for would-be users of copyrighted works to track down the owners of those works, which facilitates licensing opportunities. The mechanics of the registration process are discussed more fully in Chapters 3 and 4.

Foundations of Copyright Management

In the Introduction and Chapter 1, I write about the basics of copyright law and how the digital environment has impacted photographers and their ability to protect their use from unauthorized uses. In this chapter, I build on that basic knowledge by discussing some practical best practices that will help you manage the copyright aspects of your image library and get ready to register your works with the U.S. Copyright Office, which will help maximize your rights.

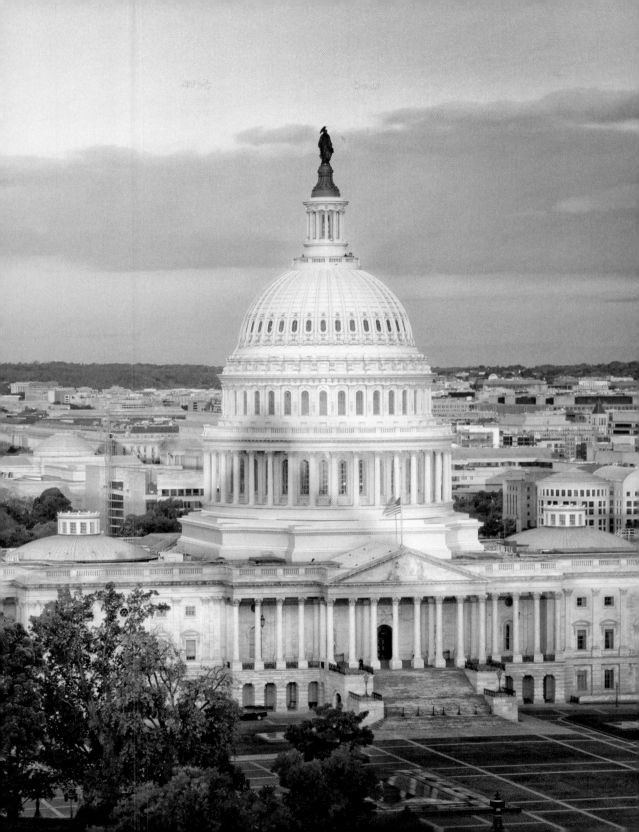

Camera Considerations

In most cases, the copyright workflow begins right in the camera. Most modern DSLR cameras have the ability to include copyright information at the moment of the image capture so that the copyright status of the image and the name of the owner are "baked into" the file. Having the information already in the image file saves time later, because most popular workflow tools, such as Adobe Lightroom, will automatically populate their databases with the information in the image metadata file upon import.

Including copyright information in the metadata of your images is a good idea because the information is tied to the image immediately upon its creation. Although virtually all workflow management and image manipulation programs let you add this information later, having it there from the moment of the file's creation ensures that if you hand off image files without any post processing (or to a third party that handles post processing for you), the images are still identified as yours.

> ## Integrity issues with metadata
>
> As I discuss more in Chapter 6, image metadata, including the copyright information, can easily be changed or removed. Unfortunately, this has become common practice on many social media sites, which strip out the metadata automatically when you upload an image. This means that if a user downloads a particular file down the road, he or she will have no idea where it came from and no way of attributing the photographer. Worse, a user with bad intent could take an image file and replace the copyright information with his or her own. This doesn't have any legal effect on your copyright, but it makes it much harder for people to track you down.

Import Considerations

The next place to ensure that your images are properly protected is during the import into your workflow software. Programs like Lightroom let you make batch changes to images, and the metadata associated with those images, during the import process, so you only have to define the settings once for the entire import. Of course, one of Lightroom's strengths is that it makes heavy use of presets, so you can accelerate your workflow

even more by establishing a standard metadata preset—complete with the relevant copyright information—to apply automatically on import. Here's how:

1. In Lightroom, from the File menu, choose Import Photos and Videos.

2. On the right-hand side of the large dialog that appears, look for the Apply During Import panel and select New from the Metadata drop-down list (or select Edit Presets if you want to add copyright information to an established metadata preset), as shown in **Figure 2.1**.

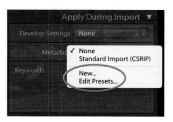

Figure 2.1 The Apply During Import panel.

The Edit Metadata Presets dialog (shown in **Figure 2.2**) appears.

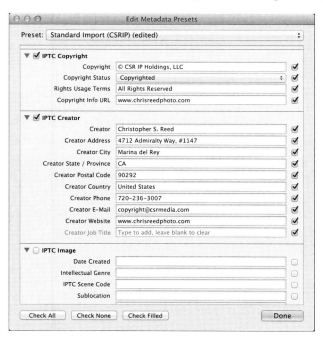

Figure 2.2 The Edit Metadata Presets dialog.

3. Scroll down to the IPTC Copyright and IPTC Creator sections and make sure that the box next to each of those items is checked.

 Those check boxes tell Lightroom to overwrite whatever information may already exist in those fields in the images that you're importing.

 Note

 In case you're wondering, IPTC stands for International Press Telecommunications Council, which developed a metadata schema for digital images that has become a global standard.

4. In the Copyright field, enter the familiar copyright symbol, ©, followed by the legal name of the copyright owner, which will generally be either your name or your company name.

 Tip

 To create the copyright symbol, press Option-G (Mac) or Alt-0169 (PC). (For the PC shortcut, use the number pad—it won't work if you use the numbers that run along the top of the keyboard.)

 Why not include the date? It is true that under U.S. copyright law, an official copyright notice includes the copyright symbol (or the words copyright or copr.), the date of first publication, and the name of the copyright owner. Because you're creating a preset to apply to newly imported photographs, I'm assuming that those images have likely not been "published" as defined by the copyright law (more on what that actually means later in this chapter), so including a date in the copyright field is unnecessary.

5. From the Copyright Status drop-down list, select Copyrighted.

 This flags the file as a copyrighted image. Some software programs will alert the user to the copyright status when opening the file; in Photoshop, for example, the copyright symbol will appear next to the filename (as shown in **Figure 2.3**). In addition, some responsible photo labs use the copyright status to identify images that may require special permission to print if they don't believe the person who submitted the file for printing is the copyright owner.

6. In the Rights Usage Terms field, type "All Rights Reserved."

This field is really intended for use by photographers who license their images to include the terms of a specific license for a specific user. This allows the licensee to keep the terms connected with the image. So, you might change this field in a particular version or edition of your image file that ends up being licensed to a third party. For now, however, since you're simply establishing a preset that will apply across the board, you can keep the language generic.

7. In the Copyright Info URL field, type whatever URL will help people find you (to discuss licensing, how to order prints, and so forth).

This is typically the photographer's own website, but it could also be a social media profile page, a Twitter page, your Flickr page, or something similar. You can list multiple URLs if you like—just separate them with a comma.

> **Note**
>
> The information you list here could be made public if you distribute image files that contain this metadata (which is really the whole point of providing the information in the first place—so people can find the owner of the image), so be careful to list only the information that you're comfortable disclosing. You may want to think twice about including a home address, for example, if you aren't comfortable having that information out there.

8. In the IPTC Creator section, complete the relevant information—it's self-explanatory.

 Typically, in the Creator field, you put the name of the individual who created the work, even if the copyright is owned under a business name.

9. When you're finished editing the fields, click Create at the bottom of the dialog (or Done if you were editing an existing preset).

Now when you import images into Lightroom, you can select the preset you just created and each of the images will be given the same metadata information.

Using multiple import presets

Lightroom offers you the ability to create multiple metadata presets, which you might want to use if you shoot for different clients or for different purposes. For example, I shoot regularly for myself and my own business, so for those images I use a preset that identifies my company as the copyright owner and me as the creator (refer to **Figure 2.3**).

Sometimes I also shoot for a client where the contract specifies that the client owns the copyright, so for those images, I have a separate preset that designates me as the creator, but the client as the copyright owner.

Similarly, I sometimes do editing work for clients who provide the underlying images. For those cases, I have yet another preset that specifically leaves the IPTC Copyright and IPTC Creator fields unchanged (by unchecking the boxes described in Step 3 above).

Of course, import presets are a powerful part of Lightroom that can do far more than just bulk copyright metadata. For more on import presets, check out Martin Evening's excellent book *The Adobe Photoshop Lightroom 5 Book: The Complete Guide for Photographers*, available from Adobe Press.

Preparing to Register

Recall from Chapter 1 that even though copyright protection arises the moment you create a copyrightable work, like a photograph, in order to maximize your protection under the law, it's a good idea to register your works with the U.S. Copyright Office. In this section, I discuss how to get your images ready for registration and how to make some key decisions that will determine how you register them. I discuss the nuts and bolts of registration in Chapters 3 and 4.

Published or unpublished?

The first decision you need to make is also perhaps one of the trickiest (and most frustrating) aspects of registering copyrights in photographs: whether the images have been "published" under the law. Because the requirements for registration differ slightly depending on whether you're registering "published" images or "unpublished" images, it's a determination that you have to make before starting the registration process.

Copyright law defines *publication* as

> the distribution of copies or phonorecords of a work to the public by sale or other transfer of ownership, or by rental, lease, or lending. The offering to distribute copies or phonorecords to a group of persons for purposes of further distribution, public performance, or public display, constitutes publication. A public performance or display of a work does not of itself constitute publication.

In the days of film photography, the decision was fairly straightforward: If the images hadn't yet been distributed to anyone (say, a client or a stock photography agency), then they would be construed as "unpublished."

But what about works posted on the Internet (say, a personal blog, or a photo-sharing site like Flickr)? On the one hand, it seems like posting images on the Internet might be considered a "distribution of copies," so under the definition above, it would be considered a publication. But it would also be a "public display," and the second part of the definition above explicitly excludes public display from the definition of publication.

Although there are various views throughout the copyright community, one dominant school of thought, and the one I follow personally, is that if you post an image to the Internet and encourage or allow users to make copies of the image—either electronically or by purchasing prints or products bearing the image, or something like that—the image is published.

If, however, you make it explicit that making copies is prohibited (through copyright notices or terms of use that expressly limit the user's rights) and/or take technical steps to prevent people from making copies (through technical measures such as disabling the right-click function; see Chapter 6 for more on techniques for limiting web access), then the images may be unpublished (that is, for public display only).

So, for example, if you post an image to your blog that contains a copyright statement in the footer, your images are probably not published. Similarly, if you post your images to a photo-sharing site and explicitly identify them as copyrighted (most such sites let you specify copyright parameters), then the image is likely not published. If, however, you upload an image to that same site and enable users to order prints or you select one of the Creative Commons licenses that many such sites include, then the image is probably published (see Chapter 6 for more on Creative Commons).

Making the right choice between "published" and "unpublished" is important because if you register your works incorrectly, the registration could be successfully challenged by your opponent in court, and you could lose your eligibility to receive enhanced damages (see Chapter 1).

 CAUTION

If you're ever uncertain about whether your works are published or unpublished for purposes of copyright registration, consider speaking with an attorney to help you make a decision and determine the best course of action.

Why does publication status matter?

Although the concept of "publication" might seem arcane, the distinction is important for more than just determining which form to file with the Copyright Office. In fact, it comes up in several places throughout copyright law. For example, whether a work is published or unpublished is a consideration in some fair use cases, and certain limitations on the copyright owner's exclusive rights apply only to published works (see Chapter 1 for some examples of limitations and exceptions). For works made for hire, the length of copyright protection is determined by the publication date, and publication status also governs the type of deposit materials that a copyright owner is required to submit along with his or her registration (although for most photographers the rules are generally the same regardless of whether the work is published or unpublished).

Determining the filing type

Once you've determined whether the work you plan to register is published or unpublished, you can move on to figuring out which registration filing approach you'll take. The Copyright Office offers three ways by which you can register your images:

- A single image on a single form

- A collection of unpublished images on one form

- A group of published images on one form

A note about Copyright Office fees

The Copyright Office charges fees for many of its services, including registration, to recover some of the cost of providing them. The law provides that the Copyright Office will periodically review its fees and adjust them when necessary, which historically has happened every three years or so. The most recent fee adjustment became effective on May 1, 2014, and the fees I quote in this book are based on that fee schedule.

The latest fee schedule is always on the Copyright Office's website, so be sure to check it before registering to make sure you have the most up-to-date information.

Note the subtle differences in descriptions: for published works, it's called a *group,* and for unpublished images, it's a *collection.* Although the distinction might seem trivial, it's legally significant, because groups and collections are two separate procedures under the Copyright Office's regulations and have slightly different requirements. The biggest practical difference between the two bulk registration options is that *collections* (unpublished) can be filed either online or on paper forms, whereas *groups* (published) can be filed only on paper forms.

Table 2.1 offers a summary of your registration options. I go into greater detail on each of these options in the following sections.

Table 2.1 Summary of Registration Options

Filing Type	Paper/eCO	Cost
Single image	Either	$55 (online)
		$85 (paper)
		$35 (single author; single claimant; online)
Unpublished collection	Either	$55 (online)
		$85 (paper)
Published group	Paper only	$65

A single image

The most straightforward registration application you can file is for a single published or unpublished image. You can file this kind of application online using the Copyright Office's online registration platform, aptly called the Electronic Copyright Office (eCO) or by filing a traditional paper form known as Form VA ("VA" stands for "visual arts"). The current cost for filing an application for a single image is $55 for applications filed online and $85 for paper applications.

The Copyright Office offers a discounted rate for what it calls a "single application," which is an application filed online for a single work by a single author (who is also the copyright owner of the work) and that is not a work for hire. So, if you took an image and you are the sole copyright owner (as opposed to your company, or some other third party) and it is not a work made for hire, then you qualify for the single application fee, which is $35.

Of course, given the volume of images that most photographers produce, even at $35, the cost of registering every image, or even your "keepers" would probably be prohibitively high. Fortunately, the Copyright Office has created two batch-submission options that will allow you to register multiple images on one application, which I discuss next.

Is batch registration legal?

Neither of the batch registration options—groups or collections—are in the Copyright Act. Because of this, some attorneys and photographer advocates believe that there is a possibility that if you register your images as groups or collections, a court might conclude that the copyright registrations are invalid.

Here's the thing: Congress has empowered the Copyright Office to come up with registration practices and procedures, and those practices and procedures are found in the regulations of the Copyright Office and have the force of law. But just as courts have the power to scrutinize laws, they can also scrutinize regulations. At least one recent court case looked favorably on regulations of the Copyright Office, but there's always some risk that a future court case will yield different results. If you remain skeptical, consult with a copyright lawyer before deciding which registration option to pursue.

A collection of unpublished images

You can file a registration application for a collection of unpublished images either online or using paper Form VA. To qualify for treatment as an unpublished collection, you must meet the following regulations of the Copyright Office:

- The collection must bear a single title that identifies the collection as a whole. The title doesn't have to be anything fancy—it could just be "January 2015 Images," for example.

- The copyright claimant (that's you) is the same for all the images and for the collection as a whole.

- All the images are by the same author, or if they are by different authors, at least one of the authors must have contributed copyrightable authorship to each image.

The regulations explicitly say that although you need to complete only one form, the registration of an unpublished collection is deemed to extend to each individual copyrightable element within the collection.

 CAUTION

Despite the clear language in the Copyright Office's regulation, a number of attorneys and other advocates for photographers have taken the position that registering works as an unpublished collection is risky because there is a chance that in the event of an infringement, a court would conclude that the "collection" is a single work and that each individual photograph within the collection is worth only its prorated share of the total damages award. If this concerns you, consider consulting an attorney before filing an application for an unpublished collection, or file individual applications for each of your images.

The registration fee for a group of unpublished images is $55 for an application completed online and $85 for a paper application. There is no limit to the number of images that each unpublished collection may contain.

 CAUTION

You cannot mix published and unpublished images together when you register using the Copyright Office's batch submission options. You must first separate out all your unpublished images and all your published images and prepare separate applications for each group. For more on published images, see the next section.

A group of published images

To file a registration application for a group of published photos, you must use paper Form VA. Although the Copyright Office has been experimenting with accepting group registrations using its online platform, as of now it remains a pilot project. You can find additional information about the project on the Copyright Office's website at www.copyright.gov.

To be eligible to file an application for a group of published photographs, you must meet the following regulations of the Copyright Office:

- The copyright owner must be the same for each of the images contained in the group.

- The photographer must be the same for each image contained in the group.

- Each photograph within the group must have been published within the same calendar year.

- You must be able to identify the date on which each image within the group was published.

Just like a registration for an unpublished collection, the Copyright Office construes the registration for a group of published photographs to extend to each photograph in the group.

The cost to register a group of published photographs is $65, which is slightly cheaper than a typical paper form for registration.

Registering edited work

Suppose you register your images right as they come off your camera as an unpublished collection. After you register, you edit a handful of images and post them online in a manner that constitutes "publication" as discussed earlier. Do you need to register those edited versions separately?

Under copyright law, the edited versions would constitute "derivative works" of the raw images covered by the unpublished collection. Any infringement of the derivatives would likely also infringe on the underlying works (the images covered by the unpublished collection registration), so your ability to sue and obtain enhanced damages remains intact.

However, to be safe, many photographers will separately register the final versions individually, noting in the appropriate fields on the application form, what makes the edited version different from the underlying raw images that were previously registered. (Chapters 3 and 4 discuss how to do that in more detail.)

For example, suppose a photographer takes three bracketed exposures that were registered as an unpublished collection and subsequently creates a new, tone-mapped high-dynamic-range (HDR) image based on those three images and registers the new HDR image separately. The second registration would be appropriate as long as

- There was sufficient additional authorship in the HDR image.

- The registration application properly notes that the underlying images were previously registered.

- The registration application describes the nature of the additional authorship that was added (for example, tone mapping, color correction, compositing, retouching, and so on).

Building routine registration practices

So far, I've discussed the threshold question of publication status and offered some basic parameters of the three major registration options, and some thoughts about registering raw images versus final, edited versions. But how does this information translate into daily practice?

My own personal practice is to register images immediately after they come off the camera, so there is no question as to whether the images are published or unpublished. I call this, somewhat uncreatively, the *shoot-by-shoot approach,* because it requires that I file a new registration every time I come back from a shoot. This works well for me because I have a relatively modest number of shoots, but if you shoot more regularly, this approach could become prohibitively expensive.

Another approach, is the *periodic approach,* in which you register all the images captured during a particular period of time. Many people who practice the periodic approach register every three months—once per quarter—so that any published images are always registered within three months of publication, as is required to be eligible for enhanced damages (see Chapter 1).

Depending on the volume of images you have, filing two registration applications (one for published, the other for unpublished) every registration period may work out to be less expensive than the shoot-by-shoot approach.

> **Tip**
> You need to separate your published images from your unpublished images and register each batch separately (if you have published images).

Finally, there is the *individual image approach,* which is just as it sounds: You file separate registration applications for each image instead of packaging them in batches. This works for photographers who produce a relatively low volume of images or want to register only those images that they deem commercially viable. Because individual image registrations are the cleanest from a legal perspective—there are no questions as to the effectiveness of the registration procedure (see "Is batch registration legal?", earlier in this chapter)—some photographers have opted to only register individual images even though it's more expensive.

Determining which approach is right for you requires a balancing of administrative convenience, legal risk, and cost. If you're uncomfortable filing batch registrations, filing individual registrations is probably a better

option, but the tradeoff is that your registration expenses will increase dramatically. If you don't want to spend that kind of money, registering in batches is still better than not registering at all.

Only you, in consultation with your financial and legal advisors, can determine what's most appropriate for you and your business. This book explains the process and the law, but ultimately how you implement copyright registration and other rights management practices depends on your individual circumstances.

Online Registration Using eCO

There are three types of registration applications of interest to photographers: single images, unpublished collections, and published groups. As of this writing, the Copyright Office allows photographers to file applications online to register the first two.

This chapter provides step-by-step guidance on how to file an application for the two categories that may be filed online, using the Electronic Copyright Office (eCO), the Copyright Office's online processing platform. Filing online offers lower fees and faster turnaround times for registration applications than you get filing traditional paper forms, so if you can file online, do—it'll save you time and money.

> **Note**
>
> The Copyright Office periodically updates its software and practices, so although the information provided in this chapter is accurate as of this writing, take a few minutes to review the information on the Copyright Office's website (www.copyright.gov) to make sure you have the most up-to-date information available.

How to Establish an Account with eCO

The first step in using the eCO system is to establish an account. The process is fairly straightforward and requires only basic personal information.

> **Note**
>
> You aren't required to provide payment information to create an account, but you will need a credit card, debit card, or checking account to pay for your registration application.

To establish an eCO account, follow these steps:

1. Go to https://eco.copyright.gov and click the "If you are a new user, click here to register" link at the bottom of the user login box (as shown in **Figure 3.1**).

Figure 3.1 Click "If you are a new user, click here to register" to establish an eCO account.

2. On the next screen (shown in **Figure 3.2**), enter your name, email, user ID, and password, as well as a security question you'll be asked if you forget your password. Click Next when you're done.

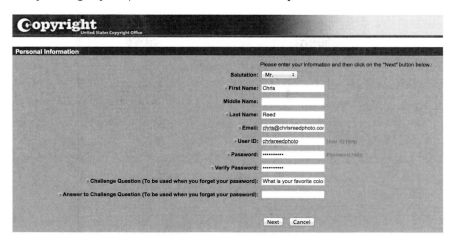

Figure 3.2 Enter your name, email, user ID, and password.

Note

Your user ID must contain at least six characters, and only letters or numbers (no special characters). Your password must be eight characters and consist of at least two letters, one number, and one special character, but not an ampersand (&).

Tip

Be sure to pick a meaningful challenge question (and one that you'll remember the answer to), so that if you need to reset your password in the future, you can do so without having to call the Copyright Office for assistance.

3. On the next screen (shown in **Figure 3.3**), enter your address, city, state, zip code, and phone number, and select your preferred contact method. Click Next when you're done.

Figure 3.3 Enter your contact information and select your preferred contact method.

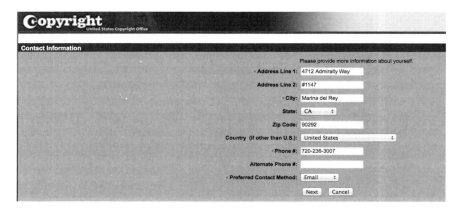

4. On the next screen, read the Usage Terms and if you agree with them, click Next.

5. On the final screen, click Finish to complete your registration.

 You'll be taken to the eCO home screen (shown in **Figure 3.4**). Here, you can begin a new application. This is also where you'll go down the road to check the status of previously started or submitted applications.

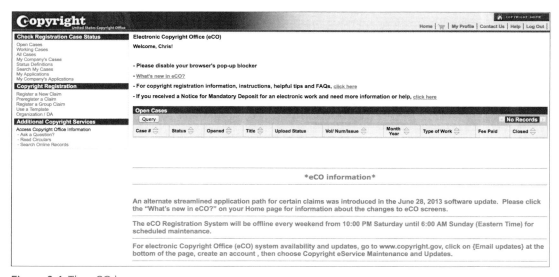

Figure 3.4 The eCO home screen.

The Registration Process

After you've established an eCO account, you can get started registering your images. In Chapter 2, I fill you in on the two types of registrations that the Copyright Office permits you to file online: single images and unpublished collections. I also explain that the Copyright Office offers a discount for what it calls "single applications," which are single works, authored and owned by the same person, that are not works for hire.

Because single applications are the most straightforward, I begin this section with a discussion of how to register a single image on the Copyright Office's single application. Then I build on that to show you how to register a single image on what the Copyright Office calls a "standard application." Finally, I explain how to register a collection of unpublished photographs.

 CAUTION!

Because the cost to file a single application is less than that of a standard application, some people are tempted to "cheat" on the questions to "force" their applications to fall into the less-expensive class. This can significantly delay the effective date of your registration, which can impact your rights if your images are infringed. Such conduct might also lead the Copyright Office to reject your application, requiring you to file a new one, which will end up costing you even more. Bottom line: Follow the rules and file the application you're supposed to file.

Filing a single application for a single image

Filing a single application is relatively straightforward:

1. From the eCO home screen (refer to **Figure 3.4**), click Register a New Claim in the Copyright Registration box on the left side of the screen.

2. The next screen (shown in **Figure 3.5**) asks three questions designed to determine whether you're qualified to use the single application or whether you need to file the standard application.

Figure 3.5 Single application screening questions.

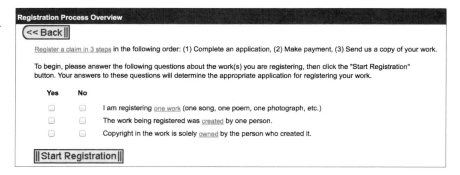

Click the Yes check box next to each of the three questions, and then click Start Registration.

3. A dialog box appears, asking you to confirm that you're entitled to file the single application. If you've made a mistake, click Cancel to revise your answers; if you're sure that you're registering a claim that is appropriate for the single application, click OK to dismiss the dialog box.

4. The next screen you see is the application home screen, from which you can see the status of the various parts of your application (see **Figure 3.6**).

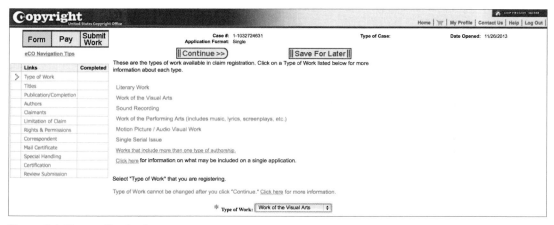

Figure 3.6 The application home screen.

5. The first step in filing your application is to select the type of work that you're registering. For photographs, select Work of the Visual Arts from the Type of Work drop-down list and then click Continue.

Links	Completed
Type of Work	✓
Titles	✓
Publication/Completion	
Authors	
Claimants	
Limitation of Claim	
Rights & Permissions	
Correspondent	
Mail Certificate	
Special Handling	
Certification	
Review Submission	

Figure 3.7 The application status indicator.

6. On the Titles screen (shown in **Figure 3.8**), enter the title of your work in "Title of this work" box. Then from the "Does this work appear in a larger work?" drop-down list, select No (since you're just registering a single image by itself). Click Continue when you're finished.

Figure 3.8 The
Titles screen.

7. On the Publication/Completion screen, from the "Has this work been published?" drop-down list, select Published or Unpublished. (See Chapter 2 for a discussion of how to determine publication status.)

 If your work is published, you're asked to provide the year of completion (the year in which you created the work), the date of first publication, and the nation of first publication.

 If your work is unpublished, all you have to supply is the year of completion.

 Click Continue when you're finished.

8. On the Author screen (shown in **Figure 3.9**), enter your name, select your country of citizenship from the Citizenship drop-down list or the country where you live from the Domicile drop-down list, enter your year of birth, and click the Photograph(s) check box.

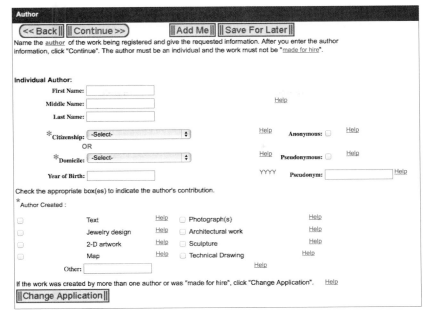

Figure 3.9 The Author screen.

> **Note**
>
> You aren't required to provide the author's name (you can register anonymously), but in most cases, you'll want to provide it.

When you're finished, click Continue.

9. On the Claimant screen, fill in your address information.

> **Note**
>
> Under copyright law the claimant can be different from the author, but because you're filing a single registration, the author and claimant must be the same. If your claimant and author are different, click Change Application to convert to a standard application.

Click Continue when you're finished.

10. On the Limitation of Claim screen, you need to provide information about the parameters of your claim—namely, whether there are any limitations. In most of cases, you can simply click Continue and move on to the next screen.

 CAUTION!

Consider speaking to an attorney if the work you seek to register contains significant portions of prior work, especially if that prior work was created by someone other than yourself. The way you describe the contours of your claim could have a significant impact on your rights, and it's important to get it correct.

Click Continue when you're finished.

11. Each of the next three screens—Rights & Permissions Information, Correspondent, and Mail Certificate—calls for contact information, some of which will be made public.

The information you provide on the Rights & Permissions Information screen will be part of the public record and may not be removed once filed with the Copyright Office. It will be made available through the Copyright Office's public database of copyright ownership information at www.copyright.gov/records; many third parties such as search engines and private public records databases also index Copyright Office data. In short, the information you provide here will be available everywhere and can often be revealed with a simple web search.

Click Continue when you've completed each of these three screens.

12. On the Special Handling screen, you have the option of requesting expedited processing, but only if you're doing so because of pending litigation, customs issues, or certain contractual or publication deadlines. Special handling is particularly expensive (over $700 at the time of this writing).

 The vast majority of claims will not require special handling, so you can skip this screen by clicking Continue.

13. The Certification screen (shown in **Figure 3.10**) is important. This is where you certify that the information you provided on the application is true and correct to the best of your knowledge.

 Before clicking the "I certify" check box, click Review Submission on the left side of the screen and carefully reread the details of your filing. If anything needs to be adjusted, click the appropriate link in the menu bar on the left to return to the relevant section. When you're satisfied with your responses, click the Certification link on the left side of the screen to return to the certification screen.

 Click the "I certify" check box and type your full legal name in the "Name of certifying individual" field.

 Click Continue when you're finished.

Figure 3.10 The Certification screen.

14. On the Review Submission screen, click Add to Cart to be taken to the My Cart page, which brings you to a fairly typical online shopping cart interface.

 At this point you can file additional applications and add them to the same cart before checking out and paying your application fees (just like any other web-based store).

15. When you're ready to check out, click Checkout. You're taken to the My Cart page, where you have two options:

 - **Pay – Deposit Acct:** This option is designed for applicants who file regularly with the Copyright Office and keep money on account to draw against when they file new applications. If you anticipate filing at least 12 applications per year, and you're willing to keep an account balance of at least $450, you can learn more about opening a deposit account by visiting www.copyright.gov/circs/circ05.pdf.

 - **Pay – Credit Card/ACH:** This option is the one that most photographers will want to select. It allows you to pay with a credit card, debit card, or automatic withdrawal from a checking account. (ACH stands for Automated Clearing House, which is the mechanism by which banks accomplish direct deposit and withdrawal transactions.)

 For purposes of this example, I'll assume you're going with this second option, so click Pay – Credit Card/ACH to be taken to the payment screen.

16. Because the Copyright Office's financial transactions are handled by the U.S. Treasury Department's Pay.gov portal, you'll be warned that you're leaving the Copyright Office website. Click OK to proceed to the payment portal.

17. When you arrive at the payment screen (shown in **Figure 3.11**), you have two options:

 - **Option 1:** Pay by having Pay.gov withdraw money from your bank account.

 - **Option 2:** Pay with a credit card.

 Enter the required information for whichever option you prefer, and when you're finished, click either Continue with ACH Payment or Continue with Plastic Card Payment, as appropriate.

Figure 3.11 The payment screen.

System Message

- The system has populated the Payment Date with the next available payment date.

Online Payment Return to your originating application

Step 1: Enter Payment Information 1 | 2

This item is payable by Bank Account Debit (ACH) or Plastic Card (ex: VISA, Mastercard, American Express, Discover)

Option 1: Pay Via Bank Account (ACH) About ACH Debit

Required fields are indicated with a red asterisk *

Account Holder Name: *
Payment Amount: $35.00
Account Type: *
Routing Number: *
Account Number: *
Confirm Account Number: *
Check Number:

 Routing Number Account Number Check Number

Payment Date: 01/08/2013

Select the "Continue with ACH Payment" button to continue to the next step in the ACH Debit Payment Process.

[Continue with ACH Payment] [Cancel]

Note: Please avoid navigating the site using your browser's Back Button - this may lead to incomplete data being transmitted and pages being loaded incorrectly. Please use the links provided whenever possible.

Option 2: Pay Via Plastic Card (PC) (ex: VISA, Mastercard, American Express, Discover)

Required fields are indicated with a red asterisk *

Account Holder Name: *
Payment Amount: $35.00
Billing Address: *
Billing Address 2:
City:
State / Province:
Zip / Postal Code:
Country: United States
Card Type: * VISA AMEX DISCOVER
Card Number: * (Card number value should not contain spaces or dashes)
Security Code: * Help finding your security code
Expiration Date: * / *

Select the "Continue with Plastic Card Payment" button to continue to the next step in the Plastic Card Payment Process.

[Continue with Plastic Card Payment] [Cancel]

Note: Please avoid navigating the site using your browser's Back Button - this may lead to incomplete data being transmitted and pages being loaded incorrectly. Please use the links provided whenever possible.

18. On the next screen (shown in **Figure 3.12**), you're asked to confirm your payment information. You also have the option to enter an email address, to which a payment receipt will be mailed. Don't forget to click the box that provides authorization to draw funds from your bank account or charge your credit card. Click Submit Payment when you're done.

Figure 3.12 The payment confirmation and authorization screen.

Online Payment Return to your originating application

Step 2: Authorize Payment 1 | 2

Payment Summary Edit this information

Address Information	**Account Information**	**Payment Information**
Account Holder Name: Christopher S Reed	**Card Type:** American Express	**Payment Amount:** $35.00
Billing Address:	**Card Number:**	**Transaction Date and Time:** 11/29/2013 12:42 EST
Billing Address 2:		
City:		
State / Province:		
Zip / Postal Code:		
Country: USA		

Email Confirmation Receipt

To have a confirmation sent to you upon completion of this transaction, provide an email address and confirmation below.

Email Address:

Confirm Email Address:

CC: Separate multiple email addresses with a comma

Authorization and Disclosure

Required fields are indicated with a red asterisk *

I authorize a charge to my card account for the above amount in accordance with my card issuer agreement. ☐ *

Press the "Submit Payment" Button only once. Pressing the button more than once could result in multiple transactions.

[Submit Payment] [Cancel]

Note: Please avoid navigating the site using your browser's Back Button - this may lead to incomplete data being transmitted and pages being loaded incorrectly. Please use the links provided whenever possible.

19. You'll see a screen saying "Your request is being processed. Please wait." After your payment is processed, you're taken to a screen where you see that your payment was successful. Click Continue to continue your application.

20. On the next screen, you have to upload a copy of your work so that the Copyright Office can examine it for copyrightability. Click Upload Deposit, which launches a separate window from which you can upload your image file.

> **Note**
>
> You must have your web browser's pop-up blocker turned off. Otherwise, the upload deposit screen won't appear.

21. In the Electronic Deposit Upload window (shown in **Figure 3.13**), click Choose File and select the file of the image for which you're registering the copyright.

> **Tip**
>
> As of this writing, the Copyright Office accepts a variety of common image formats, including BMP, GIF, JPEG, PDF, PNG, PSD, TGA, and TIFF. The current list of acceptable formats is available on the Copyright Office website at www.copyright.gov/eco/help-file-types.html.

After you've chosen the file, enter a brief title for your image. The title you enter in the Brief Title box should be the same as the title of the work you're registering (because you're registering only one work). You can see this title in the Electronic Deposit Upload window in red; in **Figure 3.13**, that's "Chris Reed Photography (Holidays 2012)."

Figure 3.13 The Electronic Deposit Upload window.

When you're finished, click Submit Files to Copyright Office.

A window appears to show you the status of your upload (see **Figure 3.14**).

Figure 3.14 The upload status indicator.

STATUS: Transferring data...

Estimated time left:	0 min 2 secs (3336 KB of 4483.1 KB uploaded)
Transfer Rate:	561.2 KB/sec

22. When your upload is complete, you're taken back to the upload screen, where you have to click Upload Complete. Your application materials will not be placed into the queue for processing by the Copyright Office unless you click that button. But once you click that button, you won't be able to upload any additional files unless you contact the Copyright Office and ask them to unlock the application.

To confirm that you've completed the upload, look in the Upload Status column, which should say "Complete."

After you've completed your application, you can return to the eCO home screen by clicking Home in the upper-right corner. There, you should see your recent application in the Open Cases list. The status should say "Open" and the upload status should say "Complete."

If everything made it through successfully, you should receive three separate emails: one confirming your payment was processed, another indicating that your application has been received, and another indicating that your deposit has been received. Although these emails are not instantaneous, they do tend to arrive within an hour or so of completing the application and uploading the deposit. Copyright Office email sometimes ends up in spam folders, so be sure to check there before troubleshooting.

If your case list doesn't indicate that your application is "Open" and/or the upload status doesn't say "Complete," or you don't receive the emails described here, you may want to retrace your steps using this book, or call the Copyright Office to confirm that everything is in order with your application.

Filing a standard application for a single image

Suppose you don't qualify for the single application because you're registering works made for hire, or you're registering your works in the name of a company instead of yourself as the individual photographer (which means the author and the copyright owner are not the same, which is one of the requirements for the single application).

In this case, you'll be automatically routed to the standard application upon properly answering the screening questions (refer to **Figure 3.5**). If

you click the No check box next to any of those questions, the eCO system will automatically launch the standard application.

The main difference between the single application procedure (described in the preceding section) and the standard application is that when you reach the Claimant screen (see Step 9 in the preceding section), you have the option of providing a claimant who is different from the author. For example, see **Figure 3.15**, where the author is an individual and the claimant is a separate entity.

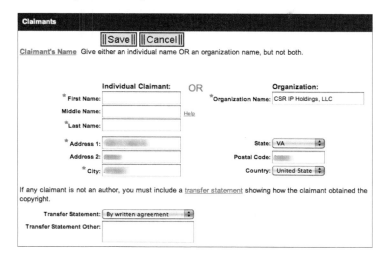

Figure 3.15 The Claimant screen.

Filing an application for an unpublished collection

The application procedure for a collection of unpublished images is largely similar to the procedure for registering a single image on a standard application, with a few tweaks along the way.

Giving your collection a title

As discussed in Chapter 2, one of the requirements of an unpublished collection registration is that the collection bears "a single title identifying the collection as a whole." So, come up with a title that describes the entire collection of images that you seek to register, such as the example in **Figure 3.13**, where the collection is called "Chris Reed Photography (Holidays 2012)." Your title should be descriptive enough that you can easily figure out later what works are covered by the registration.

Ideally, how you title your collections will be based on what registration approach you adopt (see Chapter 2 for a discussion of the individual image, shoot-by-shoot, and periodic approaches to copyright registration). The title "Chris Reed Photography (Holidays 2012)" is reflective of a shoot-by-shoot approach, where the name of the collection includes a descriptive name that I gave the shoot, "Holidays 2012." If you were registering using the periodic approach, you might include a brief description of the timeframe covered by the registration. For example, one of my periodic registrations, before I switched to a shoot-by-shoot approach, was titled "Chris Reed Photography (2011:Q1&Q2)"; it included images from the first and second quarters of 2011.

To give your collection a title, from the Titles screen (shown in **Figure 3.16**), click New*.

On the screen that follows, from the Title Type drop-down list, select "Title of work being registered" (see **Figure 3.17**). In the "Title of this work" field, type your title. Then click Save.

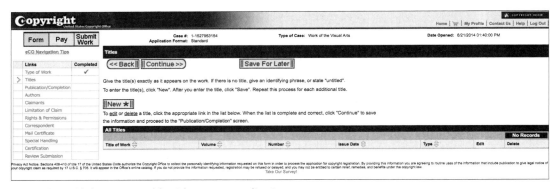

Figure 3.16 Click New* to add a title to your application.

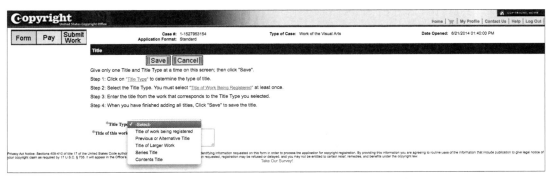

Figure 3.17 Select the type of title you're adding from the Title Type drop-down list.

You're returned to the main Titles screen. Now, click New* again and on the resulting screen, from the Title Type drop-down list, select Previous or Alternative Title. In the "Title of this work" field, type "Unpublished collection of [number of images]" and include the number of images that are in your group. In the example in **Figure 3.18**, the alternative title is "Unpublished collection of 265 images." Describing the contents of the collection in this way makes the public record more comprehensive and, therefore, more useful to someone, like a judge, trying to figure out whether a particular image was part of the registration (see "How much detail do you have to provide?" later in this chapter).

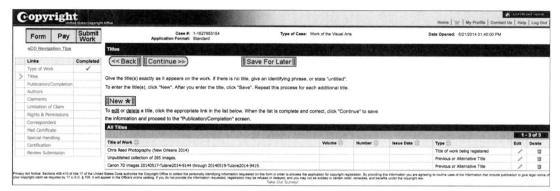

Figure 3.18 Make sure your titles are clear so that you can identify which images are in that collection down the road.

Although it isn't required, consider adding "contents titles" to list each of the elements of the collection. To do that, simply follow the same process outlined above, but select Contents Title from the Title Type drop-down list, enter the title in the "Title of this work" field, and click Save. Repeat the process for each image in the collection.

> **Note**
>
> Sometimes people attempt to enter multiple titles as a single, long text string in one Contents Title field in the online application to avoid having to repeat the process. The Copyright Office has reported that its database has trouble reading long entries. To be safe, enter an individual contents title for each image in the collection.

If the number of images in your collection is so large such that it's unreasonable to enter each one individually, consider at least entering an additional alternative title by spelling out the range of images included in the collection. For example, on one of my registrations, I included as

an alternative title "Canon 7D images IMG_4124 through IMG_4295." It produces a registration record that isn't quite as comprehensive as listing every image in the collection, but it's better than just noting that it contains a certain number of images.

<div style="border:1px solid">

How much detail do you have to provide?

Strictly speaking, the Copyright Office rules don't require that you provide contents titles for your collections, but there are some good reasons for doing so. Copyright registration is essentially a bargain with the public: in exchange for creating a public record of your copyrights, you can bring a lawsuit for infringement and to possibly obtain statutory damages and attorneys' fees. So, it stands to reason that the more information you provide to the public record, the stronger your registration will be, and the less likely a defendant will be able to defeat it in court.

Put differently, a registration record that merely says it covers 1,500 images is not as useful as one that describes each of those 1,500 images, or at the very least, provides a range of image numbers, or some other descriptive information. While it still may be of only limited use to the general public (because the Copyright Office's system is largely text based), you (or your lawyer) will be able to argue to a court that you have taken all reasonable steps necessary to provide a detailed public record, consistent with the public policy objectives of the Copyright Act.

There is no easy answer to the question "How much detail do you have to provide?" But in determining how much effort to put into a particular registration application, keep in mind the basic tradeoff: if you spend more time putting together a registration record that is as useful as it can possibly be to the public, it's less likely to be susceptible to challenge down the road.

</div>

Creating the deposit copy

If your collection contains just a handful of images, you can upload each one of your images as separate files, using the procedure described earlier, without much trouble.

If, however, you're submitting a collection of several hundred images, uploading individual image files is a laborious task. Fortunately, there is an alternative. Using Adobe Photoshop Lightroom you can create a digital contact sheet that serves as the deposit copy for the entire collection:

1. In Lightroom, switch to the Print module and set up a print with 1/2-inch margins on the left and right, and 1-inch margins on the top and bottom, with five images per row and four images per column (see **Figure 3.19**). The caption for each image should be its filename.

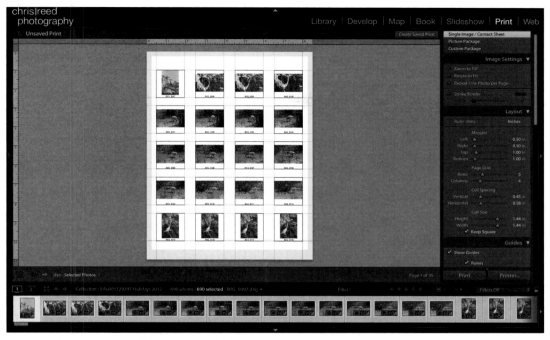

Figure 3.19 A registration deposit contact sheet set up in Lightroom's Print module.

2. To create the PDF on a Mac, click the Printer button on the lower right, and then select Save as PDF from the PDF drop-down list in the dialog box.

 To create the PDF on a PC with Acrobat Professional installed, change the printer selection to Acrobat PDF or equivalent (different systems are set up differently, so how this appears to you may differ based on your setup).

 Name the PDF file using only letters (uppercase or lowercase), numbers, underscores, or spaces so that you can upload the resulting PDF to eCO.

3. After you've created the PDF, it requires a little editing before it can be submitted to the Copyright Office. To ensure that the deposit can be easily connected to the information on the application, using Adobe Acrobat XI Pro (the most recent version at the time of this writing; almost any version will do, but the instructions provided here are based on XI Pro), add a header that includes the title of the collection, as well as the case number that the Copyright Office has assigned to your submission.

To add a header within Acrobat, open the PDF and click Tools, then click Pages, and then click Header & Footer (see **Figure 3.20**), which will launch the Update Header and Footer dialog box (shown in **Figure 3.21**).

You might also consider adding page numbers, just to make sure that a third party looking at the PDF down the road (like a judge) can tell that she's looking at the entire file.

Figure 3.20 Find the header and footer feature in Adobe Acrobat Pro.

Figure 3.21 Add a header to your registration deposit contact sheet.

What Happens Next

So, you've filed your application for registration and you've received the confirmation emails from the Copyright Office. Now what?

You wait. If all goes well, you won't hear from the Copyright Office again until you receive a certificate of registration in the mail. As of this writing, the average processing time for electronic applications is about three to five months. After your application has been fully processed and approved, you'll also see your claim show up in the Copyright Office's online database, which you can search at www.copyright.gov/records. If something is wrong with your application, you'll hear from the Copyright Office most likely by email or traditional mail. Occasionally, the copyright examiner will call. How to deal with the Office if and when a representative does get in touch with a problem is covered more fully in Chapter 5.

Registration Using Paper Forms

In Chapter 3, I discuss the process of registering your photos with the U.S. Copyright Office using the online registration platform, eCO. Although electronic registration is the preferred (and faster) method to register your images, the Copyright Office still accepts paper forms for people who prefer to file that way and for people who are registering a group of published images (a paper form is the only way to register a group of published images, at least for now). This chapter walks you through the application process using paper forms.

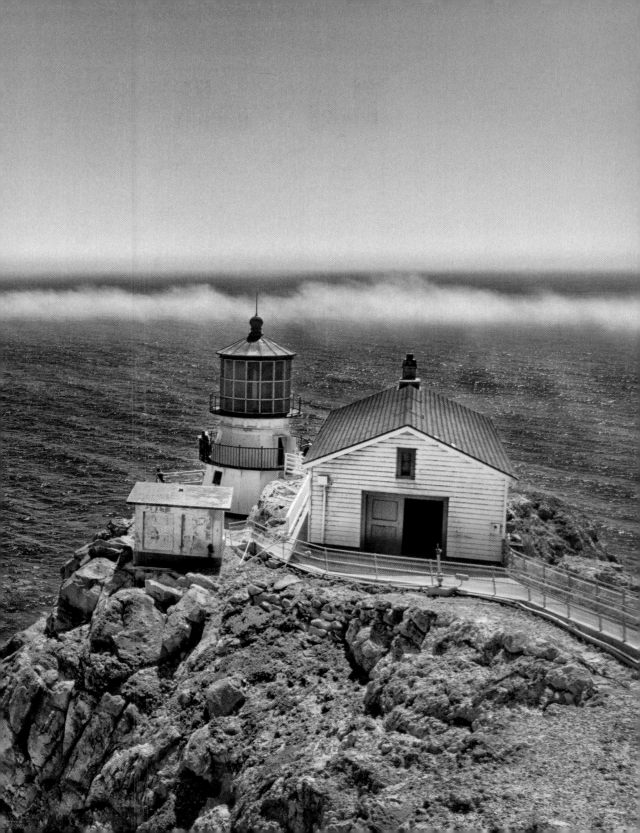

The Necessary Forms

You'll encounter two primary forms when registering images: Form VA (which stands for "visual arts") and Form GR/PPh/CON (which stands for "group registration of published photographs continuation sheet").

You can find both forms on the Copyright Office website at www.copyright.gov/forms in "fillable" format, which enables you to type your responses online and print out the completed forms, instead of having to complete the forms by hand.

The front of Form VA is shown in **Figure 4.1**; the back is shown in **Figure 4.2**.

Preparing Form VA

Form VA is the foundation of a paper application for published images, while the continuation sheet, discussed later in this chapter, adds additional information to the application (and, strictly speaking, is optional—but more on that later). I walk you through how to complete Form VA section by section here. (The Copyright Office calls each section of the form a "space." Go figure.)

Copyright Office fees are subject to change. For current fees, check the Copyright Office website at *www.copyright.gov*, write the Copyright Office, or call (202) 707-3000.

Form VA
For a Work of the Visual Arts
UNITED STATES COPYRIGHT OFFICE

REGISTRATION NUMBER

VA VAU

EFFECTIVE DATE OF REGISTRATION

Month Day Year

Privacy Act Notice: Sections 408-410 of title 17 of the *United States Code* authorize the Copyright Office to collect the personally identifying information requested on this form in order to process the application for copyright registration. By providing this information you are agreeing to routine uses of the information that include publication to give legal notice of your copyright claim as required by 17 U.S.C. §705. It will appear in the Office's online catalog. If you do not provide the information requested, registration may be refused or delayed, and you may not be entitled to certain relief, remedies, and benefits under the copyright law.

DO NOT WRITE ABOVE THIS LINE. IF YOU NEED MORE SPACE, USE A SEPARATE CONTINUATION SHEET.

1

TITLE OF THIS WORK ▼

NATURE OF THIS WORK ▼ See instructions

PREVIOUS OR ALTERNATIVE TITLES ▼

PUBLICATION AS A CONTRIBUTION If this work was published as a contribution to a periodical, serial, or collection, give information about the collective work in which the contribution appeared. **Title of Collective Work ▼**

If published in a periodical or serial give: **Volume ▼** **Number ▼** **Issue Date ▼** **On Pages ▼**

2 a

NAME OF AUTHOR ▼

DATES OF BIRTH AND DEATH
Year Born ▼ Year Died ▼

WAS THIS CONTRIBUTION TO THE WORK A "WORK MADE FOR HIRE"?
❑ Yes
❑ No

AUTHOR'S NATIONALITY OR DOMICILE
Name of Country
OR ⎰ Citizen of _____
 ⎱ Domiciled in _____

WAS THIS AUTHOR'S CONTRIBUTION TO THE WORK
Anonymous? ❑ Yes ❑ No
Pseudonymous? ❑ Yes ❑ No
If the answer to either of these questions is "Yes," see detailed instructions.

NOTE
Under the law, the "author" of a "work made for hire" is generally the employer, not the employee (see instructions). For any part of this work that was "made for hire," check "Yes" in the space provided, give the employer (or other person for whom the work was prepared) as "Author" of that part, and leave the space for dates of birth and death blank.

NATURE OF AUTHORSHIP Check appropriate box(es). **See instructions**
❑ 3-Dimensional sculpture
❑ 2-Dimensional artwork
❑ Reproduction of work of art
❑ Map
❑ Photograph
❑ Jewelry design
❑ Technical drawing
❑ Text
❑ Architectural work

b

NAME OF AUTHOR ▼

DATES OF BIRTH AND DEATH
Year Born ▼ Year Died ▼

WAS THIS CONTRIBUTION TO THE WORK A "WORK MADE FOR HIRE"?
❑ Yes
❑ No

AUTHOR'S NATIONALITY OR DOMICILE
Name of Country
OR ⎰ Citizen of _____
 ⎱ Domiciled in _____

WAS THIS AUTHOR'S CONTRIBUTION TO THE WORK
Anonymous? ❑ Yes ❑ No
Pseudonymous? ❑ Yes ❑ No
If the answer to either of these questions is "Yes," see detailed instructions.

NATURE OF AUTHORSHIP Check appropriate box(es). **See instructions**
❑ 3-Dimensional sculpture
❑ 2-Dimensional artwork
❑ Reproduction of work of art
❑ Map
❑ Photograph
❑ Jewelry design
❑ Technical drawing
❑ Text
❑ Architectural work

3 a

YEAR IN WHICH CREATION OF THIS WORK WAS COMPLETED
Year ▶
This information must be given in all cases.

b DATE AND NATION OF FIRST PUBLICATION OF THIS PARTICULAR WORK
Complete this information ONLY if this work has been published.
Month ▶ _____ Day ▶ _____ Year ▶ _____
Nation ▶ _____

4

See instructions before completing this space.

COPYRIGHT CLAIMANT(S) Name and address must be given even if the claimant is the same as the author given in space 2. ▼

TRANSFER If the claimant(s) named here in space 4 is (are) different from the author(s) named in space 2, give a brief statement of how the claimant(s) obtained ownership of the copyright. ▼

DO NOT WRITE HERE
OFFICE USE ONLY

APPLICATION RECEIVED

ONE DEPOSIT RECEIVED

TWO DEPOSITS RECEIVED

FUNDS RECEIVED

MORE ON BACK ▶
• Complete all applicable spaces (numbers 5-9) on the reverse side of this page.
• See detailed instructions.
• Sign the form at line 8.

DO NOT WRITE HERE
Page 1 of _____ pages

Figure 4.1 Front of Form VA.

DO NOT WRITE ABOVE THIS LINE. IF YOU NEED MORE SPACE, USE A SEPARATE CONTINUATION SHEET.

PREVIOUS REGISTRATION Has registration for this work, or for an earlier version of this work, already been made in the Copyright Office?
☐ **Yes** ☐ **No** If your answer is "Yes," why is another registration being sought? (Check appropriate box.) ▼
a. ☐ This is the first published edition of a work previously registered in unpublished form.
b. ☐ This is the first application submitted by this author as copyright claimant.
c. ☐ This is a changed version of the work, as shown by space 6 on this application.
If your answer is "Yes," give: **Previous Registration Number** ▼ _____ **Year of Registration** ▼ _____

5

DERIVATIVE WORK OR COMPILATION Complete both space 6a and 6b for a derivative work; complete only 6b for a compilation.
a. Preexisting Material Identify any preexisting work or works that this work is based on or incorporates. ▼

b. Material Added to This Work Give a brief, general statement of the material that has been added to this work and in which copyright is claimed. ▼

6
a
b

See instructions
before completing
this space.

DEPOSIT ACCOUNT If the registration fee is to be charged to a Deposit Account established in the Copyright Office, give name and number of Account.
Name ▼ _____ **Account Number** ▼ _____

7
a

CORRESPONDENCE Give name and address to which correspondence about this application should be sent. Name/Address/Apt/City/State/Zip ▼

b

Area code and daytime telephone number () _____ Fax number () _____

Email _____

CERTIFICATION* I, the undersigned, hereby certify that I am the

check only one ▶ {
☐ author
☐ other copyright claimant
☐ owner of exclusive right(s)
☐ authorized agent of _____
Name of author or other copyright claimant, or owner of exclusive right(s) ▲

of the work identified in this application and that the statements made by me in this application are correct to the best of my knowledge.

8

Typed or printed name and date ▼ If this application gives a date of publication in space 3, do not sign and submit it before that date.

_____ Date _____

Handwritten signature (X) ▼

X _____

Certificate
will be
mailed in
window
envelope
to this
address:

Name ▼ _____

Number/Street/Apt ▼ _____

City/State/Zip ▼ _____

YOU MUST:
· Complete all necessary spaces
· Sign your application in space 8
**SEND ALL 3 ELEMENTS
IN THE SAME PACKAGE:**
1. Application form
2. Nonrefundable filing fee in check or money
order payable to Register of Copyrights
3. Deposit material
MAIL TO:
Library of Congress
Copyright Office-VA
101 Independence Avenue SE
Washington, DC 20559

9

Figure 4.2 Back of Form VA.

Space 1

To complete space 1 (shown in **Figure 4.3**), follow these steps:

1. Under Title of This Work, write the title of your group of images.

 Your title doesn't need to be anything fancy, but it should describe the contents of the group generally—for example, "January 2015 Images" or "Canada Trip 2015." Your title might differ based on whether you adopt a shoot-by-shoot or periodic approach to registering your images (see Chapter 2 for more on this).

2. Under Previous or Alternative Titles, write "Group registration of X published photographs," where X is the number of images contained in the group.

3. Under Nature of This Work, write "Photographs."

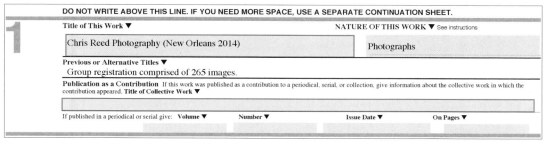

Figure 4.3 Space 1 of Form VA.

Space 2

To complete space 2 (shown in **Figure 4.4**), follow these steps:

1. Under Name of Author, enter your name (assuming you're the photographer).

2. Under Dates of Birth and Death, enter the year you were born. Unless you're a ghost (or you're registering a copyright for someone who has died), you can skip the year of death.

3. Under "Was this contribution to the work a 'work made for hire'?," check No.

4. Under Author's Nationality or Domicile, write the country you're a citizen of *or* the country where you reside.

 It's up to you which one you provide, but the law requires you provide one or the other.

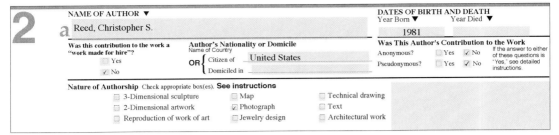

Figure 4.4 Space 2 of Form VA.

5. Under Was This Author's Contribution to the Work, check No twice, unless you're registering anonymously or under a pseudonym (both of which are rare—after all, part of why you're registering your copyright is to be a part of the public record).

6. Under Nature of Authorship, check the Photograph box.

Space 3

To complete space 3 (shown in **Figure 4.5**), follow these steps:

1. Under Year in Which Creation of This Work Was Completed, enter the year in which you made the newest photograph in the group.

 So, for example, if your group contains images made over a three-year period ranging from 2011 to 2014, you would enter "2014" here.

2. Under Date and Nation of First Publication of This Particular Work, if all the photographs in the group were published on the same date in the same country, enter the month, day, and year, as well as the nation in which they were published.

> **Tip**
>
> If you don't know the exact date, provide your best estimate, but write "approximately" in the margin.

If the photographs were published on different dates, provide the range of dates.

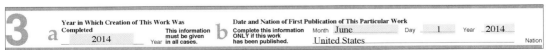

Figure 4.5 Space 3 of Form VA.

Space 4

In space 4, provide the copyright claimant name and address, which in most cases will be the same as the photographer.

Space 5

In space 5, you must disclose whether you've previously registered a version of the images for which you're completing the form. In most cases, you can simply check No and move to the next section.

However, if your photographs contain substantial elements from prior work, you should check Yes and then also check "This is a changed version of the work, as shown by space 6 on this application." If the prior work is registered, you must also provide the registration number and year of registration in the space provided.

CAUTION!

If the work you're registering contains significant portions of prior work, especially if that prior work was created by someone other than yourself, talk to an attorney. How you describe the contours of your claim could have a significant impact on your rights, and you want to get it correct.

Space 6

Space 6 is only for derivative works or compilations. If this applies to you, briefly describe the original work and the material you added or changed, as appropriate. Odds are, you'll just skip this section.

Space 7

If you have a deposit account with the Copyright Office, you need to complete space 7a. Chapter 3 provides more information about deposit accounts. Most people don't have deposit accounts, so you'll probably skip space 7a.

In space 7b, provide the contact information for the person you'd like the Copyright Office to correspond with if they have questions about the application. In most cases, this will be you.

Space 8

Space 8 requires you to certify that the information stated in your application is true and correct to the best of your knowledge. Assuming you're registering for yourself, check the Author box. Print and sign your name, and date it.

Space 9

In space 9, provide the address where the Copyright Office should mail your certificate. The certificate will be prepared from a scan of the application form and folded so that what you type here will appear in a windowed envelope.

Preparing the Continuation Sheet and Deposit Copies

Once you've completed Form VA, which provides general information about the group of images you're registering, it's time to provide some more specific information about each of the images, which is where the continuation sheet comes in. Copyright Office regulations require that you provide the date of publication for each photograph included in the group, and the continuation sheet is one way to do that. Strictly speaking, the continuation sheet is one of several ways to provide the publication dates (the other options are to include the date on each image itself or on a hardcopy or text file list that is submitted with the images).

The information you provide on the continuation sheet will become part of the registration certificate so that anyone looking at the certificate itself—like a court in the case of an infringement lawsuit—can tell, by title at least, which images are part of the registration. Putting the dates of publication on the images themselves will also help tie together the deposit and the certificate, creating a more complete public record. For that reason, I strongly recommend both submitting the continuation sheet and including additional information on the face of the image itself, as I discuss in this section.

The continuation sheet

Completing the continuation sheet (shown in **Figure 4.6**) is pretty straightforward:

1. In space A, provide the name of the author and the name of the copyright claimant *as they appear on Form VA.*

 It's very important that the information you provide in this section matches *exactly* the information you provide on Form VA.

2. Space B is where you briefly describe each photograph, including the date of publication. Number each image in your filing sequentially in the Number box. For each image, you have to provide the title and the date and nation of first publication. You may also provide a brief description, but that's not required.

 Typically I use the filename as the title, but if you usually give your images unique titles, feel free to use those. What's important is that the title is descriptive enough that you can identify later which image

CONTINUATION SHEET
FOR FORM VA
for Group Registration of Published Photographs

◯ Form GR/PPh/CON
UNITED STATES COPYRIGHT OFFICE

REGISTRATION NUMBER

USE ONLY WITH FORM VA

EFFECTIVE DATE OF REGISTRATION

(Month) (Day) (Year)

CONTINUATION SHEET RECEIVED

Page _____ of _____ pages

- This optional Continuation Sheet (Form GR/PPh/CON) is used only in conjunction with Form VA for group registration of published photographs.
- This form *may not* be used as a continuation sheet for unpublished collections. To list individual titles in unpublished collections, use Form CON.
- If you do not have enough space for all the information you need to give on Form VA or if you do not provide all necessary information on each photograph, use this Continuation Sheet and submit it with completed Form VA.
- No more than 50 continuation sheets (or 750 photos) may be used with a single filing fee and Form VA.
- If you submit this Continuation Sheet, clip (do not tape or staple) it to completed Form VA and fold the two together before submitting them.
- Space A of this sheet is intended to identify the author and claimant.
- Space B is intended to identify individual titles and dates of publication (and optional description) of individual photographs.
- Use the boxes to number each line in Part B consecutively. If you need more space, use additional Forms GR/PPh/CON.
- Copyright fees are subject to change. For current fees, check the Copyright Office website at *www.copyright.gov*, write the Copyright Office, or call (202) 707-3000.

DO NOT WRITE ABOVE THIS LINE. FOR COPYRIGHT OFFICE USE ONLY

A
Identification of Application

IDENTIFICATION OF AUTHOR AND CLAIMANT: Give the name of the author and the name of the copyright claimant in all the contributions listed in Part B of this form. The names should be the same as the names given in spaces 2 and 4 of the basic application.

Name of Author _____

Name of Copyright Claimant _____

B
Registration for Group of Published Photographs

COPYRIGHT REGISTRATION FOR A GROUP OF PUBLISHED PHOTOGRAPHS: To make a single registration for a group of works by the same individual author, all published within 1 calendar year (*see instructions*), give full information about each contribution. If more space is needed, use additional Forms GR/PPh/CON. Number the boxes.

Number []

Title of Photograph _____

Date of First Publication _____ (Month) _____ (Day) _____ (Year) Nation of First Publication _____

Description of Photograph _____ (Optional)

Number []

Title of Photograph _____

Date of First Publication _____ (Month) _____ (Day) _____ (Year) Nation of First Publication _____

Description of Photograph _____ (Optional)

Number []

Title of Photograph _____

Date of First Publication _____ (Month) _____ (Day) _____ (Year) Nation of First Publication _____

Description of Photograph _____ (Optional)

Number []

Title of Photograph _____

Date of First Publication _____ (Month) _____ (Day) _____ (Year) Nation of First Publication _____

Description of Photograph _____ (Optional)

Number []

Title of Photograph _____

Date of First Publication _____ (Month) _____ (Day) _____ (Year) Nation of First Publication _____

Description of Photograph _____ (Optional)

Figure 4.6 Form GR/PPh/CON (also known as the continuation sheet).

it's referring to. It's also important that the title you provide on the continuation sheet is the same as the title you provide on the deposit copy itself (see the next section), which is why I find using the filename to be the best approach.

Each continuation sheet contains space for 15 images. If you have more than that, use additional sheets of paper, but continue numbering sequentially (that is, the first number on your second continuation sheet would be 16).

> **Note**
>
> I regularly have trouble with the first entry on each form getting slightly cut off to the point that it's difficult to read (see **Figure 4.7**). I usually end up writing the first entry by hand after I print the form just to make sure it's clear.

Figure 4.7 For some reason, the first entry often ends up being cut off, so you may want to leave this blank and fill it out by hand after you print the form.

> **Note**
>
> Copyright Office regulations allow no more than 50 continuation sheets per application. Because each sheet contains space for 15 images, you're limited to 750 images per registration application. If you have more than 750 images to register at one time, you need to file more than one application (and pay more than one registration fee).

3. In space C, provide the address where you want the Copyright Office to mail the certificate. It may seem redundant to have to do this on Form VA as well as on each continuation sheet, but it helps ensure that none of the pages gets separated (and if they do, it makes it easier to track down the rest of the application).

Once you're finished with the continuation sheets, it's time to create the deposit copies of each image that's part of the group.

Deposit copies

Preparing the deposit copies is fairly straightforward, especially if you're using Adobe Lightroom, because you can partially automate the process using export presets and an inexpensive plugin called LR/Mogrify 2, which is available from www.photographers-toolbox.com. You can download a trial version of the software for free, but it's limited to exporting only ten images at a time. You can unlock the full version of the software by making a small donation (any amount that you choose) to the software developers.

After you've installed LR/Mogrify 2, you can easily produce deposit images with the following steps:

> **Note**
>
> This process may seem a little lengthy and laborious, but a lot of it is setup work that you can save as a preset, so next time you register, you won't have to go through all this again. Spending a little time upfront will save you a lot of time down the road.

1. In Lightroom, select one image from the group that you're registering. With that image selected, from the File menu, choose Export.

 The Export One File dialog box (shown in **Figure 4.8**) appears.

Figure 4.8 The Export One File dialog box in Lightroom.

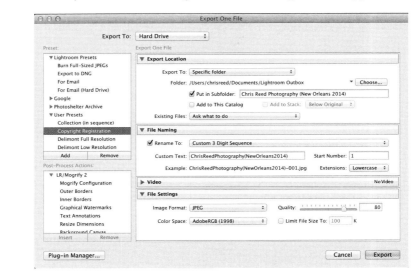

2. In the Export Location panel of the Export One File dialog box, designate a location on your computer to store the deposited images.

I have a master folder called "Lightroom Outbox" that I use to stage output from Lightroom, and inside of that I have Lightroom create separate folders for each export. You can do this by checking the Put in Subfolder box and then giving the folder a name.

As shown in **Figure 4.9**, the name of the folder is the title from my registration application, "Chris Reed Photography (New Orleans 2014)." You can call the folder whatever you want (it really doesn't matter for copyright registration purposes). Just be sure to remember where your images are going to be saved so you can find them again later.

Figure 4.9 Tell Lightroom where to save your finished files.

3. In the File Naming panel of the Export One File dialog box, check the Rename To box and select Edit from the drop-down list (see **Figure 4.10**).

Figure 4.10 Select Edit from the drop-down list.

The Filename Template Editor dialog box (shown in **Figure 4.11**) appears.

Figure 4.11 The Filename Template Editor dialog box.

4. In the Filename Template Editor dialog box, select Custom Name – Sequence from the Preset drop-down list. In the text field, you should have a template filename that says "Custom Text – Sequence # (1)," which is a great start, but you need to make one adjustment: Delete the "Sequence # (1)" part. Then under the "Sequence and Date" heading, select Sequence # (001) (see **Figure 4.12**) from the top drop-down list, and click Insert.

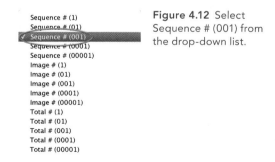

Figure 4.12 Select Sequence # (001) from the drop-down list.

This will add a sequence variable to the template filename, but with placeholders for three digits, which will help keep your images organized properly. When you're finished, go back up to the Preset drop-down list at the top of the dialog box, select Save Current Settings as New Preset, and give the filename preset a name. You can call it whatever you like, but I decided to call it Custom 3 Digit Sequence.

When you're finished, click Done.

5. Back in the File Naming panel of the Export One File dialog box, in the Custom Text field, type the name of your group but without spaces (some computer systems still have difficulty parsing filenames with spaces).

In my example, it's "ChrisReedPhotography(NewOrleans2014)," as shown in **Figure 4.13**.

Make sure the Start Number is set to 1. The idea is to output a batch of images that are numbered sequentially and that relate to the image descriptions that you provided on the continuation sheet in the last part of this chapter. **See the Caution note on page 84 for circumstances in which you'll want to change this number.**

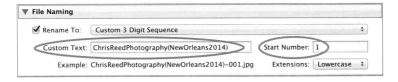

Figure 4.13 Use the name of your group registration as the filename (without spaces) and start the numbering at 1.

6. In the File Settings panel of the dialog box, set the image format to JPEG and the quality to 80.

There is no need to limit the file size, and the color space isn't important for copyright registration purposes.

7. In the Image Sizing panel of the dialog box, check the Resize to Fit box and select Long Edge from the drop-down list. Set the sizing parameter to 1000 pixels and a resolution of 240 pixels per inch (see **Figure 4.14**).

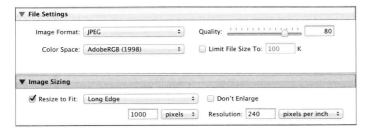

Figure 4.14 Set the file settings as shown here.

8. Now find the list of post-process actions in the lower-left corner of the Export One File dialog box. You should see a list of options under LR/Mogrify 2, as shown in **Figure 4.15** (you may need to expand this list by clicking the arrow on the left).

 Select Outer Borders and click Insert; select Inner Borders and click Insert; and finally, select Text Annotations and click Insert.

 You should now see three additional panels in the list of export options on the right side: Mogrify Outer Border Options, Mogrify Inner Border Options, and Mogrify Text Annotations.

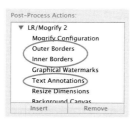

Figure 4.15 Activate the LR/Mogrify plug-in by selecting the actions shown here.

9. In the Mogrify Outer Border Options panel (shown in **Figure 4.16**), click the + button to add an outer border. Uncheck the "Identical borders" box and make sure that all the drop-down lists are set to Pixels. Then type 30 for the left and right sides, and 50 for the top and bottom. If it isn't already set, change the border color to black by clicking the color swatch (mine defaults to black, so I don't usually need to do anything to the color).

Figure 4.16 Set the outer border options as shown here.

10. Now switch to the Mogrify Inner Border Options panel (shown in **Figure 4.17**), and click the + button to add an inner border. This time, make sure the "Identical borders" box is checked and that all the drop-down boxes are set to Pixels. Now set the inset to 0 and the size to 1. The color should be set to white (again, the default for me, so you may not need to change it), and set the opacity to 100%.

Figure 4.17 Set the inner border options as shown here.

11. Now switch to the Mogrify Text Annotations panel (shown in **Figure 4.18**). Uncheck the "Add annotation before outer borders are applied" box. Next to the Font name field, click Choose. This part is a little odd—instead of giving you a list of installed fonts, it provides a list of the raw font files in your system fonts directory. Select a simple font—I usually go with Myriad because it ships with Adobe products and it's nice and legible.

 Set the font size to 24 pixels, the color to white, and the opacity to 100% (again, all defaults for me, but if they aren't for you, go ahead and make the change). Set the font orientation to horizontal (the radio button with the letter A *not* on its side), the horizontal inset to 30 pixels, and the vertical inset to 20 pixels.

Figure 4.18 Set
the text annotation
options as shown
here.

12. In the "Define your text" field, write the name of your group
 registration.

 Again, in this example it's "Chris Reed Photography (New Orleans
 2014)," which is consistent with the filename I selected and what I
 wrote on the application form.

 Select the text position radio button to place the text in the upper-left
 corner of the image (refer to **Figure 4.18**).

13. At the top of the Mogrify Text Annotations panel, click the + button to
 add another text field. You see everything you just typed disappear,
 but don't worry—it's still there. Use the arrow icons on the left side of
 the panel to switch between text fields (refer to **Figure 4.18**).

14. In the new text field, apply the same settings as in the first text field
 (from Steps 11–12) except change the vertical inset to 15 pixels and
 change the text position radio button to place the text in the lower-
 left corner of the image.

15. Under the "Define your text" field, click Add Token (see **Figure 4.19**).
 The Select a Token dialog box appears. From the Basic Tokens drop-
 down list (see **Figure 4.20**), select "Leaf name of EXPORTED file."

 You're taken back to the Mogrify Text Annotations panel and the
 variable {exportedName} is added to the text field.

Figure 4.19
Click Add Token under the "Define your text" field as shown here.

Figure 4.20 Select "Leaf name of EXPORTED file" from the Basic Tokens drop-down list.

> **Note**
>
> This procedure assumes that your image title for registration purposes is the filename. Because the LR/Mogrify plugin lets you put whatever text variables you like, you could just as easily use the IPTC Headline field (which many photographers use as a title field). The important thing is that whatever ends up on the resulting images is consistent with what you put on the continuation sheet, so that the Copyright Office examiner (and perhaps a judge down the road) can determine which images are described on the registration certificate.

16. Click the + button in the upper-right corner of the Mogrify Text Annotations panel to add one more text field to your images. Apply the same settings as in Steps 11–12, except change the text position radio button so that the text will appear in the lower-right corner of the image. In the "Define your text" field, type "Date of first publication: [date]" where you insert the date the image(s) were published (see **Figure 4.21**).

Figure 4.21 Set the first text annotation as shown here.

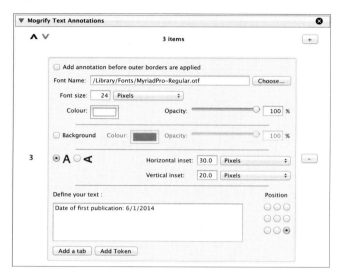

 CAUTION!

This process only partially automates the creation of your deposits. Because there is no "date of first publication" metadata field, the portion of this process that adds the date to the image files is partially manual. For example, if you had batches of images within your group that were published on June 1, June 7, and June 25, you would have to export the June 1 batch, change the date in your export settings, and then export the June 7 batch, and so on. *Be very careful to also change the sequence start number* (see Step 5) for your subsequent batches so that you don't inadvertently overwrite your first images—Lightroom will start at 1 unless told otherwise in the export settings.

One other option may be to use some other metadata field to contain the date of first publication and then use that metadata variable in the text field. I don't personally practice this approach because I want to preserve the metadata fields for their intended purpose, but if you're interested in finding a way to make this process a little more automated, that's one way to do it.

17. When you're finished, save your export settings as a preset by clicking the Add button at the bottom of the Preset box (see **Figure 4.22**). Give your preset a name (I called mine "Copyright Registration") and click Create (see **Figure 4.23**).

Figure 4.23 Give your preset a name.

Figure 4.22 Save your preset so you don't have to go through all this setup work again!

Now for future registrations all you'll have to do is update a few fields (the name of the group of the images, the date of first publication, and the folder where you want Lightroom to save your images).

18. Click Export to export the image you selected in Step 1 (it'll be in the folder you picked in Step 2). You should end up with an image that looks similar to the one shown in **Figure 4.24**. If you don't, go back and retrace the steps in this section. If it worked, you can go ahead and delete the image because it was just a test.

Figure 4.24 Your export preset should create an image that looks similar to this, with a black border and the text annotations as shown here.

19. Now that you've saved and tested the preset, it's finally time to export your images. Select the first batch of images from your group that were published on the same day.

It may be one image, or it may be multiple images, but the key here is to make sure that all the images you select were published on the same date. Once you've made your selection, select Export from the File menu within Lightroom to launch the Export dialog box.

20. In the Export dialog box, select the preset that you created in Step 17 and scroll down to the Mogrify Text Attributes panel. Make sure the name of the group is still accurate, and then use the arrow icons on the left side of the panel to cycle through the other text elements until you get to the one you created in Step 16 (the one where you typed "Date of first publication"). Change the date here to reflect the date that the images selected in Step 19 were published (see **Figure 4.25**). Click Export.

Define your text :

Date of first publication 6/27/2014

Figure 4.25 Change the date as shown here to reflect the date of publication for the images you select. In this example, the images were published on June 27, 2014.

21. Repeat Steps 19 and 20 for each subset of images within your group— that is, select the next batch of images within the group that were published on the same day (Step 19) and change the text annotation so that the date is properly rendered on the exported images (Step 20).

Be sure to also change the sequence start number (see Step 5) for each export so that you don't overwrite any files. For example, if your first subset contains 25 images, when you repeat the process for the next subset, you'll want to change that Start Number in the File Naming panel to 26.

22. When you're finished exporting all your images, check the folder where Lightroom has saved the files, and check the file count.

You want to make sure that the total number of files there is the same as the number of images you provided in the Previous or Alternative Title field (see "Space 1," earlier in this chapter). The Copyright Office will look to make sure that your deposit copies match the information provided on the application, and submitting an incomplete deposit is a quick way to have your application rejected, so it pays to take the time now to get it right. You should also make sure that the filenames

match the titles you provided on the continuation sheet, and that the numbers on the continuation sheet (the ones on the left side of the form) match the sequence numbers on the files you just exported.

23. Once you're finished exporting the files, burn them to a CD or DVD so you can send them to the Copyright Office with your deposit. Then, on the label-side of the disc, write your name, address, and phone number; the title of the group of images; and the number of images in the group.

Preparing the Payment and Mailing the Application

Now you have a completed Form VA, a completed continuation sheet, and a CD or DVD containing all your images, annotated with the date of first publication on each one. The only part that's missing is the application fee.

You must include either a check or money order with your application for the full amount of the fee, payable to the Register of Copyrights. As of this writing, the fee for Form VA is $85, but always check the Copyright Office website at www.copyright.gov to ensure you have the most up-to-date fee information. Although not required, I typically paperclip my check to the form to help make sure that the check doesn't get lost when the mail gets opened. (I recommend against stapling because it could damage the application form when the Copyright Office pulls off the check, which could make it more difficult to process.)

> **Tip**
>
> Remember that the effective date of registration is the date that the Copyright Office receives the application, payment, and deposit, in acceptable form (not the date that the Copyright Office processes it). Because of this, it's important to get everything right the first time; otherwise, your effective date might get pushed out. For example, if you send in your application, but the check isn't for the full amount of the registration fee, the Copyright Office will contact you and ask for a new check, but the effective date will become the date they receive the new check.

I highly recommend that you put the disc containing your images in a hard plastic case rather than a plastic or paper sleeve. I've found that discs sent without adequate packaging often get crushed or can snap in half as they

go through mail sorting equipment. For that same reason, I also strongly recommend sending your application in a small box, rather than a padded envelope.

The U.S. Copyright Office is located on Capitol Hill in Washington, D.C., and because of that, its mail is subjected to intense security screening procedures, including irradiation. It's also subject to lengthy delays getting from the post office to the Copyright Office's mail intake facility. You can shorten that time somewhat by using an express courier such as UPS or FedEx. Although it costs a little more than regular mail, the packages are traceable and I've found they're less likely to get damaged on their way to the Copyright Office. If you do use regular mail, consider sending it using delivery confirmation or by certified mail with a return receipt. Because the effective date of your registration is based on the date everything is received by the Copyright Office, it's useful to have that date for your records.

> **Tip**
>
> Make a copy of everything that you send to the Copyright Office before you package it up. In the event that your application materials get lost, it can be very helpful to have an exact duplicate in your files. In addition, if the Copyright Office contacts you about your application, it can be helpful to see exactly what the Copyright Office staff are looking at when you speak with them.

When you're ready to send your application materials, mail them to:

U.S. Copyright Office—VA
Library of Congress
101 Independence Ave. SE
Washington, DC 20559

What Happens Next?

So, you've mailed off your application for registration. Now what?

Just like filing an electronic application, you wait. Track your package using the courier's website and, after it has been delivered, print out the page that has the date and time of delivery and keep it with your copy of the application. It's easy to overlook this step, but having evidence of delivery can be very helpful if your application gets misplaced once it makes it to the Copyright Office (it doesn't happen often, but it does happen).

Ideally you won't hear anything from the Copyright Office until your certificate arrives in the mail, but don't expect that to happen anytime soon. As of this writing the processing time for paper applications is 7 to 14 months, and perhaps even longer to get into the Copyright Office's online database (www.copyright.gov/records) because the process of moving the data from the application to the database is still done by hand.

If there is a problem with your application, you'll hear from the Copyright Office likely by mail or email. Sometimes the copyright examiner will call. The next chapter covers how to deal with the Copyright Office if and when a representative gets in touch with a problem.

After Applying for Registration

In the last several chapters, I walk through the basics of copyright registration using both the Copyright Office's online system and paper forms. Once your application is out the door, you'll receive a registration certificate, a rejection, or perhaps a follow-up inquiry from the Copyright Office. This chapter explains how to deal with post-application questions and refusals to register. I also offer some suggestions for keeping well-organized records of your copyrights.

Handling Questions from the Copyright Office

In the best-case scenario, the next time you hear from the Copyright Office will be by mail, when you receive a certificate of registration (see **Figure 5.1**). If you filed using eCO (see Chapter 3), your certificate will be printed using the information you typed into the system. If you filed using paper forms (see Chapter 4), your certificate will essentially be scanned in and reprinted on Copyright Office certificate paper (including the continuation sheet, if you filed one).

Sometimes, though, the Copyright Office won't immediately issue a certificate, because the copyright examiner has questions about your application. In even rarer circumstances, the Copyright Office may refuse to issue a registration.

Inquiries about your application

Probably one of the most common reasons the Copyright Office has to contact an applicant is to clarify information on the application that is inconsistent or to get information that is missing. For example, someone might indicate that a work is published, but then not provide any publication details (or vice versa). This happens far more frequently with paper forms, because the online system has built-in safeguards that generally prevent you from selecting options that don't make sense with each other.

Another common mistake is providing information on the application—electronic or paper—that doesn't match information on the deposit copy. For example, you might have put a date of first publication on the continuation sheet that doesn't match the information on the deposit copy itself. Even though there is no requirement that you provide the date in both places (recall from Chapter 4 that I recommend doing both even though the law only requires one), the fact that the information is inconsistent will very likely trigger an inquiry from the Copyright Office.

Sometimes it's just a simple oversight, which was the case with a registration application I filed several years ago. I had neglected to provide a date of publication for one of the images in the group, so the examiner wrote to me and asked (see **Figure 5.2**). I replied (see **Figure 5.3**), and the Copyright Office ultimately issued the registration.

Certificate of Registration

This Certificate issued under the seal of the Copyright Office in accordance with title 17, *United States Code*, attests that registration has been made for the work identified below. The information on this certificate has been made a part of the Copyright Office records.

Maria A. Pallante

Register of Copyrights, United States of America

Registration Number

VA 1-862-159

Effective date of registration:

February 26, 2013

Title

Title of Work: Lone Star State

Completion/Publication

Year of Completion: 2013

Date of 1st Publication: February 24, 2013 **Nation of 1st Publication:** United States

Author

■ **Author:** Christopher S Reed

Author Created: photograph(s)

Citizen of: United States **Domiciled in:** United States

Year Born: 1981

Copyright claimant

Copyright Claimant: CSR IP Holdings, LLC

1600 S. Eads St., #830N, Arlington, VA, 22202, United States

Transfer Statement: By written agreement

Rights and Permissions

Organization Name: CSR Media, LLC

Email: copyright@csrmedia.com **Telephone:** 720-236-3007

Address: 1600 S. Eads St.

#830N

Arlington, VA 22202 United States

Certification

Name: Christopher S. Reed

Date: February 26, 2013

Page 1 of 1

Figure 5.1 When the Copyright Office approves your application for registration, you'll receive a certificate that will look similar to this.

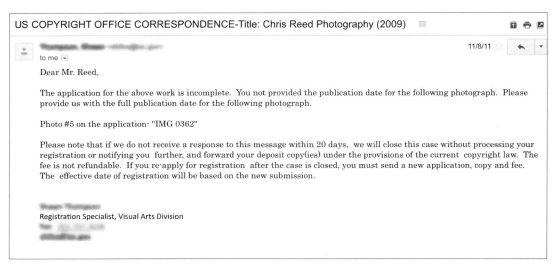

Figure 5.2 The Copyright Office may contact you for clarification or to fix omissions on your submission.

Figure 5.3 Typically, the Copyright Office's concerns are resolved by simply providing basic factual responses to the questions asked.

If the Copyright Office needs to follow up with you and you filed your application using eCO, the copyright examiner will most likely contact you by email; if you filed on paper, the examiner may contact you by phone, email, or traditional letter. In any event, it's nothing to be afraid of and nothing to worry about. The Copyright Office staff's principal objective is to make sure that the record they create—and the certificate you receive—accurately reflect the scope of the copyright claim. They're not out to get you, and they aren't trying to stop you from registering your work. Although dealing with their questions can sometimes be frustrating, ultimately having an accurate record benefits everyone, including you in the event you have to bring an infringement lawsuit later and need to rely upon the information in the registration.

Most correspondence from the Copyright Office will indicate that you need to reply within 20 days. Although the rumor is that you technically have a little more time to respond, you should do your best to reply within that timeframe. The Copyright Office is generally pretty forgiving when it comes to mail delays and the like, but try not to abuse it. The copyright law gives the office pretty broad discretion to close abandoned application files and keep the fees (which are nonrefundable), so if you push it too far, you may find yourself paying another application fee because you let an application languish.

 CAUTION!

In the unlikely event that the questions from the Copyright Office raise legal issues that you don't know the answer to, you may want to consider consulting a lawyer before responding. What you send to the Copyright Office becomes part of the public record for your registration (though it may not be accessible through the Copyright Office's online database, it is still considered part of the record and is accessible by visiting the Copyright Office). Because of that, anything you write back to the Copyright Office could be used in court later, so it's important to get it right.

Tip

Although the Copyright Office operates an information line that you can call for general inquiries about copyright registration (877-476-0778 or 202-707-3000), if you're contacted by a copyright examiner I strongly encourage you to respond to the examiner directly through the contact information he or she provides. Sometimes people try to circumvent the examiner by contacting the general number instead, but that can often just confuse the record and ultimately lead to things taking longer than they should.

Refusal to register

In relatively rare instances, the Copyright Office will refuse to issue a registration. Although the reasons for refusal vary, one of the most common is that the material submitted isn't "original" enough (in the copyright sense) to be copyrightable. An increasing problem in photography, and visual arts in general, is the growth of computer-generated art, which may contain little or no human authorship. If it's clear from the application that a computer created a particular work, without any human intervention, then the Copyright Office would likely refuse to register the work.

Requesting reconsideration

Refusals are issued in writing and will clearly explain the basis for the refusal, including references to the law or Copyright Office regulations, as appropriate. If your registration is refused, you have two options: you can live with it, or you can request a reconsideration, but the Copyright Office must receive the request for reconsideration no more than three months after the date of refusal.

The Copyright Office's reconsideration process has two tiers. The first reconsideration is reviewed by the Copyright Office's Registration Program—the department within the Copyright Office that makes registration decisions. If the Registration Program upholds the examiner's refusal to register, you may request a second reconsideration, which is taken to the Copyright Office's Board of Review, which is comprised of the Register of Copyrights (the director of the Copyright Office), the Office's general counsel (the top lawyer), and the Associate Register for Registration Policy & Practices (the head of the Registration Program), or their designated staff.

Filing a request for reconsideration is a fairly straightforward process. All you really need to do is write a letter that sets forth the reasons why you think your work is entitled to a registration and why you think the Copyright Office improperly refused the registration. The Copyright Office recommends that you include the control number from the rejection letter (which may be listed as a service request [SR] number or a case number), but I encourage you to photocopy the refusal letter and include it with your own letter. That way the Copyright Office can see exactly what registration file you're writing about. Also, be sure to note on the first page whether you're seeking a first or second reconsideration, and the fee, in the form of a check payable to the Register of Copyrights. As of this writing, based on the May 2014 fee schedule, the cost to file a first request for reconsideration is $250, and the cost for a second reconsideration is $500.

 CAUTION!

Because reconsiderations often require making legal arguments about why the Copyright Office misapplied the law in your particular circumstances, you might want to consider hiring an attorney to handle the request. This is one of those cases when you need to do a cost-benefit analysis to determine whether it's worth the expenditure. Only a lawyer can help you make that determination.

When you're ready to mail your request for reconsideration, write "RECONSIDERATION" on the outside of the envelope somewhere so that it gets routed properly when it arrives at the Copyright Office. I strongly suggest mailing your request via certified mail with a return receipt requested (unfortunately, requests for reconsideration must be sent to a post office box, so you can't use a private carrier like UPS or FedEx), so you can document the date the Copyright Office received it. Mail the request to:

U.S. Copyright Office
ATTN: RECONSIDERATION
Receipt Analysis and Control Division
P.O. Box 71380
Washington, DC 20024-1380

Unfortunately, the Office does not publish expected turnaround times for requests for reconsideration. For some time, there was a significant backlog of requests, but that was recently eliminated, so although turnaround times have improved, they're still unpredictable.

Living with rejection

So, suppose you've used your two requests for reconsideration and the Office still refuses to register your work. Or, suppose you don't want to shell out the money to pursue reconsideration. Now what? In Chapter 1, I explain that you must register your work before you can sue for infringement, and while that's a good rule of thumb, it's not the whole story. The law actually requires that you must have *applied for* registration; you can still get into court if you show you've been refused registration, but it makes your case a little more complicated.

Basically, if you sue for infringement and show up with a refusal to register instead of a certificate of registration, you'll have to prove in court that your work is copyrightable, whereas with a certificate, the court gets to make the assumption that your work is copyrightable (and the other side

would have to prove that it isn't, if they wanted to make that argument). Using a refusal to register to get into court also gives the Copyright Office an opportunity (but not an obligation) to get involved in the case, presumably to assert before the court why your work is not copyrightable.

The idea of having to go to court and argue that your work is copyrightable may seem a little daunting, but it's important to remember that in the vast majority of cases, registrations for photographs are granted and everything is fine. I included this discussion in this book so you'd have a sense of the full copyright registration landscape.

Maintaining Your Records

While registering your work with the Copyright Office is arguably one of the most important steps you can take in protecting your work, there are a few administrative things to do on your end to make sure that your records are in order and that you can access the relevant information about your copyrights when you need it.

Registration certificates and deposits

The vast majority of applications for registration are successful and result in the issuance of a registration certificate. The Copyright Office still issues paper certificates, which means that if you register your work regularly, you'll end up with a pile of paper (especially if you're filing paper applications with continuation sheets, which can quickly become voluminous if you register more than a handful of images). Because copyright registration certificates are printed on special paper, at first glance they all look the same, so they can quickly get mixed up without some sort of organizational system.

There is no right or wrong way to file your registration certificates. I have a relatively simple process that works for me:

1. Scan the registration certificate into a PDF and include the registration number and the title of the registered work in the filename. I also include the abbreviation "Cert" in the filename, so I know it's the certificate.

 For example, I registered images from a recent shoot in Barcelona as an unpublished collection (see Chapter 3) titled "Chris Reed

Photography (Barcelona 2013)" (using a shoot-by-shoot approach; see Chapter 2). I was issued registration number VAu001139321. So, the filename of the certificate is VAu001139321-Barcelona2013-Cert.pdf. (To keep the filename a reasonable length, I drop the "Chris Reed Photography.")

2. If you filed using eCO, you should have a PDF contact sheet that you submitted as a deposit copy (see Chapter 3). Rename that file following the same structure as in Step 1, except replace "Cert" with "Deposit."

So, for the example above, it would be VAu001139321-Barcelona2013-Deposit.pdf.

If you filed on paper, you should have a folder on your computer containing JPGs that you submitted to the Copyright Office on DVD or CD (see Chapter 4). Compress those files into an archive file (ZIP or equivalent) and name it similarly. Again, using the example above, it would be VAu001139321-Barcelona2013-Deposit.zip.

3. Save the two files (the one from Step 1 and the one from Step 2) together in a directory on your computer.

I have a folder called "Copyright Registration Records" on my computer, divided into subfolders by year. This approach lets me find them easily if I know when I registered the images, and putting the registration number and title in the filename lets me use my computer's search feature to find them if I can't remember the date.

4. That leaves you with a paper registration certificate. Although you just scanned the certificate in Step 1, I strongly encourage you to maintain the original because you may need it down the road for litigation or some other circumstances that requires you to establish ownership. The Copyright Office will issue reprints of certificates for a fee, but you can avoid paying again by maintaining good recordkeeping practices in the first place.

I keep my registration certificates in file folders, sorted by year. Depending on how many you have, you might also consider putting them in three-ring binders, sorted by year.

Don't feel compelled to necessarily follow this process—find something that works for you and that fits with your existing recordkeeping practices. What's important is that you have a decent organizational scheme and can find information relatively quickly when you need it.

> **Note**
>
> Although copyright registration certificates are important documents, they're merely records of a copyright ownership claim, and they don't represent the claim itself. This is a little different from other important documents you may have come across, like stock certificates or even checks, where the value of the asset it represents goes with the document. So, although you should keep certificates in a safe, easily accessible place (so you don't have to pay the Copyright Office to issue a replacement), you don't generally need to worry about keeping them in a safe deposit box or anything like that.

Updating your Lightroom catalog

Keeping the certificates and deposit copies in a safe and easily identifiable location is a great start to your copyright registration recordkeeping, but the other half of the equation is to make sure that your electronic database is up-to-date. After all, that's where most of your work probably takes place.

Here's my relatively straightforward process:

1. Switch to the Library module in Adobe Lightroom and create a collection set called "Copyright Registrations" by clicking the + icon in the Collections panel and selecting Create Collection Set (as shown in **Figure 5.4**).

 The Create Collection Set dialog box appears.

2. Give your collection set a name.

 I called mine "Copyright Registrations," but you can call it whatever you'd like. Make sure the "Inside a collection set" box is unchecked, and click Create (see **Figure 5.4**).

Figure 5.4 Create a new collection set to organize your registered images.

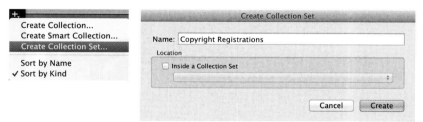

3. Click the + icon again in the Collections panel, and select Create Collection, as shown in **Figure 5.5**.

The Create Collection dialog box appears.

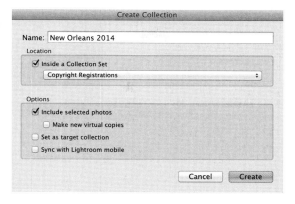

Figure 5.5 Create a new collection for each of your registration filings.

4. Give your collection a name.

I typically use the title that I provided the Copyright Office as the title of this work on the registration form. If you've already selected the images that are part of the collection or group, go ahead and check the "Include selected photos" box. If you haven't selected the images, leave that box unchecked. You can easily drag them into the collection after you create it. When you're done, click Create.

5. Once you've created the collection, switch to Grid mode if you're not already in it, and select all the images in the collection by pressing Command-A (Mac) or Ctrl-A (PC).

6. Find the Metadata panel on the right-hand side and make sure that you have IPTC selected from the drop-down list at the top of the panel (see **Figure 5.6**).

Figure 5.6 Select IPTC from the metadata options.

Unfortunately, while the IPTC metadata standard includes certain copyright-related fields (like the copyright status of the work and certain identifying information about the copyright owner), it does not include a place to include the copyright registration number.

There are two ways to handle this: one is to select some other IPTC field that you don't typically use and put the registration information there instead. That's what I've been doing for many years, using the JobID or Job Identifier field in the Workflow section, as shown in **Figure 5.7**.

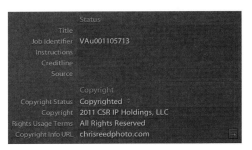

Figure 5.7 You can use the IPTC Job Identifier field to hold the copyright registration number because the standard IPTC copyright fields do not include space for registration information.

The major drawback of this approach is that it's inconsistent with the IPTC standard. The whole point of having an international standard like IPTC is that everyone using it speaks the same language, and by using a field for something that it isn't intended for, you could cause confusion down the road if you distribute images that contain that metadata to some organization (say, a stock photo agency) that does use that field. So, for your own internal purposes, it's probably fine, but a much cleaner way to incorporate copyright registration information into your images is to use a Lightroom plugin that effectively extends the software's metadata capabilities. PLUS for Lightroom is a tool from www.photographers-toolbox.com that incorporates dozens of additional metadata fields from the PLUS standard (see the nearby sidebar, "The PLUS Registry," for more on PLUS), including copyright registration number (see **Figure 5.8**). As of this writing, the plugin is about $50.

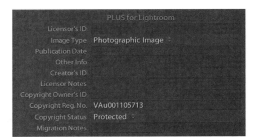

Figure 5.8 If you license the PLUS for Lightroom plugin, you can put the copyright registration number in the field intended for that purpose.

Regardless of which method you choose, the purpose of this step is to record the registration number in the metadata of the images that are registered under that number. Enter the registration number in the field of your choice (see **Figure 5.8**). Because you have multiple image files selected, Lightroom may warn you that you're trying to bulk-update the metadata (see **Figure 5.9**). Click Apply to Selected and Lightroom will make the update to your catalog.

Figure 5.9 Click Apply to Selected after confirming that you want to update each of the selected images with your new metadata.

> **Tip**
>
> If I file electronically using the Copyright Office's eCO system (see Chapter 3), I often record the case number in the metadata until I receive the registration certificate, at which point I replace the case number with the registration number. The point is simply to always know which registration filing relates to which images.

Updating the Public Record

The public benefit of copyright registration is that it creates a record of copyright ownership. But creating the record through the registration process is really only half the story. Keeping the record up-to-date so it contains meaningful information for the public is also an essential part of the process. That's why the law also provides a mechanism for updating registration records after they're created.

Recording transfers, licenses, and other documents

If you buy or sell a house, a copy of the deed and information about the transfer gets recorded in the county's registry of deeds. Similarly, if you buy or sell a car, typically that information gets recorded at the state's motor vehicle department. Copyrights are no different: when you buy or sell a copyright, or grant a license to it, you can record that information with the Copyright Office so that the transaction is part of the public record. Unlike cars and houses, though, there is no *requirement* that you

record copyright-related documents with the Copyright Office. Indeed, the vast majority of copyright transactions never get recorded, and probably don't need to be—but you should be aware that it's possible. It's called *document recordation,* and the law on it is pretty broad: It says you can record "any transfer of copyright ownership or other document pertaining to copyright." So, essentially, anything you want on the record relating to your copyrighted work, you can document with the Copyright Office.

The PLUS Registry

Although the Copyright Office operates the official registry of copyright ownership for the United States, its system presents significant challenges for photographers, the biggest of which is that its database is primarily text based. The Copyright Office is well aware of the system's shortcomings and is working to develop solutions, but beyond the government's work, there are private organizations working to improve the copyright landscape for photographers.

The PLUS Coalition, a nonprofit organization representing the interests of all imaging industry stakeholders, is working to develop its own registry that will provide more robust information about visual art, the authors who create it, and the individuals and companies that license it. PLUS has developed its own metadata standard for communicating image rights information, including ownership information (hence, the PLUS for Lightroom plugin that I mention earlier in this chapter) and licensing information (so if you license an image to a client, you can embed the terms and conditions of the license right into the file).

PLUS also operates its own registry, which supplements the copyright registration database at the Copyright Office. Although registering your images with PLUS is not a substitute for copyright registration and cannot confer the same legal benefits as copyright registration does, registering with PLUS can be enormously helpful in circumstances where a would-be image licensee is trying to find you, or your images, and can't because of the limitations on the information that the Copyright Office is able to provide. PLUS will incorporate image search technologies to make it easier and faster to identify copyright owners in ways that the Copyright Office systems simply can't accommodate right now.

Eventually, there may come a day when the Copyright Office database is seamlessly integrated with PLUS (indeed, integration with third-party databases is one of the Copyright Office's areas of interest expressed in recent discussions), but even before that happens, the benefits of registering with PLUS are significant. You can visit the PLUS Registry at www.plusregistry.org, and you can learn more about the metadata scheme and other PLUS developments at the PLUS Coalition website, www.useplus.org.

As you might expect, it's mostly major corporations whose business relies on copyright that use the copyright recordation system regularly. When a motion picture studio buys the rights to a screenplay, for example, it will record that transaction with the Copyright Office so that the public record reflects that the studio is the lawful owner of the work. If there is ever a dispute over who owns a work (say, if an author transferred the same rights to two different parties and told each party the deal was exclusive), courts would look to who recorded the transaction first to determine who actually owns it.

Odds are, you won't ever need this, so I won't go into a detailed description of how to do it, but to learn more, check out *Circular 12: Recordation of Transfers and Other Documents* from the Copyright Office, available on its website at www.copyright.gov.

Changing existing registrations

Although you may not need to encounter the recordation system very often, you may find yourself needing to change your address or perhaps other aspects of a registration record. In reality, the Copyright Office never changes an original registration record, but it can be supplemented with new information. Someone who obtains a registration record from the Copyright Office, and looks at it as a complete file, would see the supplemental material along with the original registration information. As a result, the Copyright Office calls this kind of filing a "correction or amplification," and the only way to do it is using a paper form, Form CA, which is available on the Copyright Office's website at www.copyright.gov; the filing fee is $130 as of this writing (but be sure to double-check with the Copyright Office before filing Form CA).

Unfortunately, Form CA is also the only way to change the address on your copyright registration records. If you think $130 to change your address on a registration record is steep, you're not alone. Stakeholders have been clamoring for years for the Copyright Office to find a way to do easy, cheap (ideally free) updates to basic information in registration records, but the office has been approaching the topic very cautiously, because the easier you make it to change registrations, the easier it becomes for someone with bad intent to change things that he or she shouldn't be changing (think of it as copyright identity theft). That said, the Copyright Office is very well aware of the need to make improvements to its system and is taking steps to move in that direction (see "Registration upgrades project" in Chapter 3).

CHAPTER 6

Sharing, Selling, and Licensing Images

By now, you've taken the steps necessary to maximize the copyright interests in your work. You've incorporated appropriate metadata into your images and registered them with the U.S. Copyright Office. Now it's time to "get them out there"—to license images, sell prints, or just share them with your friends, family, and perhaps the Internet community at large.

There are many reasons why you might want to put your images online. It may be as simple as sharing images with friends and family (social media has become the new family photo album), or it may be that you want to try to make some money with your work by selling prints or licensing your images. Whatever the reason, you very likely want to take steps to make sure that people can't take your work without permission, or use it in ways that you didn't intend.

Of course, putting your work on the Internet means, in many ways, giving up a certain degree of control over the work. Short of never posting anything online, there is no way to fully eliminate the risk of image piracy—if it's online, there is a very real chance that somebody, somewhere will take it unlawfully. So, the goal is to minimize the instances of image theft and maximize the instances of legitimate engagement with your audience—whether through buying or licensing your work, or just enjoying it in the way you intended.

> **Tip**
>
> Think about your goals. If you don't intend to make money from your images, then the degree to which you're concerned with protecting them might be very different from someone who makes his or her living from photography.

This chapter presents a number of issues, strategies, and techniques related to protecting images online, but unlike some of the previous chapters, it isn't intended to be a comprehensive "how to," nor is it intended to prescribe a particular method or approach. Instead, think of this chapter as a toolkit—some of the tools here may be useful to you, while others may not fit with your objectives. It's entirely up to you which tools you ultimately incorporate into your workflow.

> **Note**
>
> Because the primary audience for this book is people who are either professional or aspiring professional photographers, I often refer to "selling" images, but most of the concepts apply just as well if you're just "sharing" your images. Also note that when I say "selling," I mean selling copies of images (prints and products), as well as licensing images for stock use (see Chapter 1 for an explanation of the distinction between selling and licensing).

Three Principles of Online Image Distribution

No matter what your ultimate objective, I've found that best practices for selling images online can be boiled down to three simple rules:

- Make your work very easy to access.

- Make your work a little bit difficult to steal.

- Be reasonable.

I'll discuss each in turn.

Make your work very easy to access

I'm always amazed when I come across a photographer's website that showcases stunning work, but it's virtually impossible to figure out how to buy or license it. Of course, some photographers may not want to sell or license their work, and that's fine, but I'm talking about situations where photographers are clearly in business but making it hard to actually *do* business with them.

A familiar refrain among those who favor weakening copyright protection is that copyright owners have done a poor job of making work available through lawful sources. For example, many people still argue that the explosion of peer-to-peer file sharing services in the late 1990s and early 2000s would never have happened but for the record labels' refusal to make music available in digital form on a song-by-song basis. Of course, the market eventually evolved (many lawsuits later) and that's essentially how music is marketed and delivered today—on a song-by-song basis through online sources.

Putting aside the fact that the file sharing services and websites were flagrantly infringing, there is something to be said for making content available in the way that your customers want to consume it. To be sure, there will always be a subset of people who are intent on stealing copyrighted work, but we'll very likely never convert them. The goal really is to drive as many people as possible to become buyers. In photography, if you make it really, really easy to buy a print or license an image, you'll decrease (even if it's very slightly) the likelihood that someone will be inspired to simply right-click, save your image, and use that version instead.

There are dozens of web-based solutions for photographers interested in selling and licensing works online. At one end of the spectrum are those services that offer complete platforms for showcasing your work, as well as licensing or selling copies of individual prints. Examples of this kind of service include Zenfolio (www.zenfolio.com), SmugMug (www.smugmug.com), and PhotoShelter (www.photoshelter.com), which allow you to build comprehensive web-based portfolios that are seamlessly integrated into e-commerce-enabled galleries. These services usually offer various customization options, ranging from templates to complete customization using your own code. Typically through an affiliation with certain professional labs, these platforms enable you to offer a wide variety of prints and products to consumers; the platform handles the payment, the lab partner handles printing and fulfillment, and you receive the proceeds, based on prices you set, less a processing fee.

> **Note**
>
> You'll notice that I mention PhotoShelter a lot in this chapter. That's not because they've paid to be included or given me a free subscription or anything like that (they haven't—I pay them every year just like everybody else). I use PhotoShelter as an example simply because it's the service I know best. Other services offer very similar features, and if you're looking for a photo platform, it definitely pays to check out the various options and find one that best suits your needs. Many offer free trial periods so you can really explore the functionality.

At various places in the middle of the spectrum are the photo sharing sites with a social dimension to them. Examples include 500px (www.500px.com) and Crated (www.crated.com), which typically offer some limited customization and the ability to sell prints and products and license images, but aren't quite as flexible as the platform sites I mentioned earlier. For example, 500px offers photographers an opportunity to license images, but the terms of the license are fixed by 500px; as a photographer, you either opt in or opt out, but you can't change the terms. In comparison, on PhotoShelter, you can set up as many different license options as you like. Which option is right for you, of course, depends entirely on your own objectives.

Toward the other end of the spectrum are the consumer-facing image sharing sites such as Snapfish (www.snapfish.com) and Shutterfly (www.shutterfly.com), which are really designed for consumers to share images with friends and family, but which also offer some sales capability but usually without any profit going to the photographer. In addition, the breadth of the product line is generally limited to a handful of basic sizes and more gift-oriented products. There also usually isn't an opportunity to customize the user experience or incorporate your brand into the site. Because

of that, these sites probably aren't ideal for most professionals or aspiring professionals, but they might fill the bill if your primary objective is simply to share images with a close group of people.

At the other end of the spectrum are purely social-driven sites such as Facebook (www.facebook.com), Instagram (www.instagram.com), Twitter (www.twitter.com), Pinterest (www.pinterest.com), and the like. These sites encourage sharing of images, but typically provide no easy way to monetize the images (and worse, they often strip out the copyright information). They also often allow for multiple layers of distribution. For example, you might post an image on your business Facebook page, and your followers can essentially reshare that content making it available on *their* friends' pages.

Make your work a little bit difficult to steal

Whereas the first principle is about making it easy to get your work legally, the second principle is about making it difficult to get it illegally. But I say "a little bit difficult," because if you go too far, it can have the opposite effect.

Have you ever been in a retail establishment with signs everywhere telling you that you're being watched? It's a little offputting, and it's the same in the online space. I once visited a photographer's website that made me click through *three* separate pages, each containing various copyright notices and threats about legal action if I used his images unlawfully, before I ever got to the homepage. Had I not been doing research for this book, I probably would have just left the site and not bothered with it.

In the retail environment, most establishments have adopted more subtle approaches, such as using "greeters" who welcome visitors to the store, but also send the message that they're aware of your presence, or tagging high-margin merchandise with small devices that trigger an alarm if someone tries to take it out of the store. Similarly, there are some simple steps you can take to make it a little bit difficult to steal your work:

- Adding watermarks to your images
- Adding digital watermarks to your images
- Adding image borders
- Preventing users from right-clicking on your images
- Limiting the image size and resolution

In this section, I walk you through each of these techniques.

The tactics discussed in this section are not intended to be all-or-nothing solutions. You'll find they're most effective when used together, in ways that fit the specific distribution channel or platform that you're thinking about using. For example, you might choose to upload only watermarked images (or images with borders), no more than 800 pixels on their longest edge, on sites for which you have no control over the right-click functionality, whereas on your own portfolio site hosted by a professional image management platform where you can limit access more effectively, you might make available larger, non-watermarked versions. Some photographers never post content directly to third-party sites; instead, they post content only to their own sites and then merely post links to third-party services.

How you approach some of the techniques described in this section may also depend on the nature of the images you're posting. For example, I typically treat grab-shots that I take with my iPhone differently than I do the images that take days to edit and get into their final form. (That's not to say that you can't make some stunning images with an iPhone, but for me those tend to be the ones in that I put less creative investment into.) How that distinction shakes out for you may be very different, but it's something to think about.

Adding watermarks to your images

Some photographers assert that watermarks ruin the artistic integrity of the image. Others believe that without watermarks, their images will end up all over the web. And some even erroneously believe that without a watermark they'll lose their copyright. Whether you watermark your images has to do with your goals.

Landscape photographer Nate Zeman has an outstanding discussion of why watermarks work for him on his website (www.natezeman.com/gallery/watermarks). He recognized that people were stealing his images and figured he might as well get some promotional value out of it, so he started adding watermarks so that people seeing the stolen images would at least be able to track him down if they wanted to buy a print. "I just see it as free advertising," he wrote. Interestingly, Nate also observed that for the most part, "it's only photographers who don't like, or even notice, watermarks" and because his business focus is selling limited-edition prints to art collectors, the fact that other photographers tend not to like watermarks is largely irrelevant.

Adding a simple watermark to your images is straightforward and can be done easily from within Adobe Lightroom using the watermark editor:

1. After selecting the image(s) that you want to apply a watermark to, go to the File menu and choose Export to open the Export dialog box.

2. In the Export dialog box, scroll down to find the Watermarking panel. Select the Watermark check box and select Edit Watermarks from the drop-down list (see **Figure 6.1**). The Watermark Editor dialog box (shown in **Figure 6.2**) appears. You'll see a live preview of what your watermark will look like in the left-hand side of the box.

Figure 6.1 Select Edit Watermarks to open the Watermark Editor dialog box.

Figure 6.2 The Watermark Editor dialog box is where you'll set up the specifics for your watermark.

3. The first decision you'll need to make is whether you want to use a text watermark or a graphical watermark, such as your logo (the example in **Figure 6.2** is a text watermark). To make your selection, choose either Text or Graphic at the top of the dialog box (see **Figure 6.3**).

Figure 6.3 Select whether you want a text or graphic watermark.

If you select a graphic watermark, in the Image Options panel, you'll need to point Lightroom to either a JPEG or PNG file containing the image you want to use.

> **Tip**
>
> I recommend using a relatively large, transparent image, and allowing Lightroom to scale it down. If you use an image that's too small, it will appear pixelated and may be difficult to read.

If you select a text watermark, you can change the font and color, and add a drop shadow if you want, in the Text Options panel (see **Figure 6.4**).

Figure 6.4 For text watermarks, use the Text Options panel to change the font and color, and add a drop shadow if you want.

4. Regardless of whether you select a text or graphic watermark, you'll have several options for adjusting the appearance of the watermark in the Watermark Effects panel (see **Figure 6.5**). For some reason, they've put what I believe is the most important option last: the anchor point.

The anchor option lets you select which part of the image the watermark appears in. Changing this on an image-by-image basis allows you to place the watermark in a location that best suits the image.

Some photographers have adopted the philosophy that the watermark should appear in the least offensive area of the image, while others prefer to put the watermark over the most interesting part of the image on the theory that that's the part people will want to steal. Whatever your philosophy, it's the anchor point that lets you adjust the watermark's location.

Figure 6.5 Adjust the appearance of your watermark with the settings in the Watermark Effects panel.

There are several other options you may also want to adjust: The Opacity slider changes the intensity of your watermark (the example in **Figure 6.2** is shown at 100% opacity); the less opaque your watermark, the less it interferes with the appearance of your image.

The Size option, as you might imagine, enables you to manually make the watermark bigger or smaller, or select one of the automatic sizing options (Fit or Fill) if you want the watermark to appear across the entire image. Finally, the Inset option lets you adjust the margins, or how far from the edge of the image the watermark appears.

5. Once you've set up your watermark, you'll want to save it as a preset so you can use it again. To do this, select the drop-down list at the top of the Watermark Editor dialog box and select Save Current Settings as New Preset and then give your watermark settings a name and click Create (see **Figure 6.6**). When you're finished in the watermark editor, click Done.

Figure 6.6 Save your watermark settings so you'll be able to easily use them again.

6. Now, when you're ready to export your images, you can simply select the watermark you just saved from the drop-down list in the Watermarking panel of the Export dialog box (see **Figure 6.7**).

Figure 6.7 Select your saved water-mark from the drop-down list in the Watermarking panel.

In addition to adding watermarks to your files directly, many of the professional photo management sites, such as PhotoShelter and SmugMug will let you apply a watermark from within the platform, which allows you to upload clean images to the service and have the watermark added at the point at which the image is displayed to the user. This makes sense if you're using the platform to sell prints or products, or license images, because you'll want to be able to easily produce the clean, full-resolution image for buyers or licensees, while showing casual visitors to your site the watermarked version. **Figure 6.8** shows the watermarking feature in PhotoShelter, which allows you to control the size and position of the watermark.

If you're a little more ambitious, and you want to incorporate a watermark more artistically, check out "Creative Watermarking—How to Integrate Your Signature into Your Photos" from Klauss Herrmann at Farbspiel Photography, available at www.farbspiel-photo.com/learn/hdr-cookbook/creative-watermarking. His technique allows you to create a watermark that's placed creatively within an image so that it blends in seamlessly

and doesn't look as intrusive as traditional watermarks. As Klauss notes, because the watermarks appear to be a natural part of the scene, "a thief needs to notice them first to remove them, and removing them can be tricky."

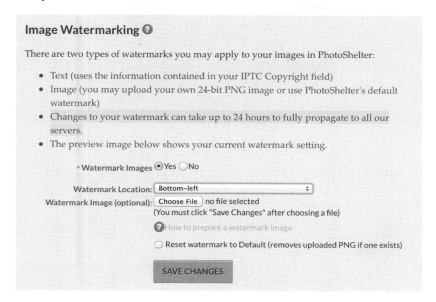

Image Watermarking ❓

There are two types of watermarks you may apply to your images in PhotoShelter:

- Text (uses the information contained in your IPTC Copyright field)
- Image (you may upload your own 24-bit PNG image or use PhotoShelter's default watermark)
- Changes to your watermark can take up to 24 hours to fully propagate to all our servers.
- The preview image below shows your current watermark setting.

 * Watermark Images ⦿ Yes ◯ No

Watermark Location: `Bottom-left` ▲▼
Watermark Image (optional): [Choose File] no file selected
(You must click "Save Changes" after choosing a file)

❓ How to prepare a watermark image

☐ Reset watermark to Default (removes uploaded PNG if one exists)

[SAVE CHANGES]

Figure 6.8 Professional photo sharing services such as PhotoShelter support basic watermarking from within the platform.

Adding digital watermarks to your images

In addition to visible watermarking (discussed in the preceding section), there are technologies available that let you embed an invisible, digital watermark into your images that can be tracked as they move around the web. One of the dominant providers of such technology is Digimarc, which has been integrated into Photoshop for many years. Digimarc watermarks are imperceptible to the naked eye, but the information embedded in the watermark can help lead people back to you and your website if they find your image online. Digimarc claims its watermarks can survive compression, encryption, cropping, and even format changes.

Although you can embed basic Digimarc data into your images using Photoshop, and interpret Digimarc data using its free reader tool, for enhanced features such as image search reports, you'll need to establish a paid account with Digimarc; paid accounts are offered at various levels depending on the number of images that you're looking to track. For more information on its services and technology, visit www.digimarc.com.

Adding image borders

If you're uncomfortable with the idea of watermarking your images, you might consider adding a border around the image that includes your logo, copyright, or additional information. This approach is not as intrusive to the image as a watermark, but it still attaches your name or logo to the image file itself. It's true that a nefarious user could still crop out the image, but remember, our goal here is to minimize image theft, knowing that we'll never completely eliminate it.

One easy way to add a border is to use the Lightroom plugin LR/Mogrify, which I discuss at length in Chapter 4 in the context of preparing copies of images for the Copyright Office's registration process. The process for creating borders for image security purposes is more or less the same, except a lot less formal because there aren't any legal requirements we're trying to satisfy here.

I'm going to walk through how to create the borders shown in **Figure 6.9**, but because there are no rules here, you should feel free to experiment as you start to get the hang of things.

1. Begin by selecting an image you'd like to add borders to in Lightroom. With the image selected, go to the File menu and choose Export to open the Export dialog box. Select Burn Full-Sized JPEGs from the Lightroom Presets list on the left, and make sure the Export To drop-down list at the top is set to Hard Drive (see **Figure 6.10**). Set your export location which is where Lightroom will save the exported files; it can be anywhere so long as you remember where it is.

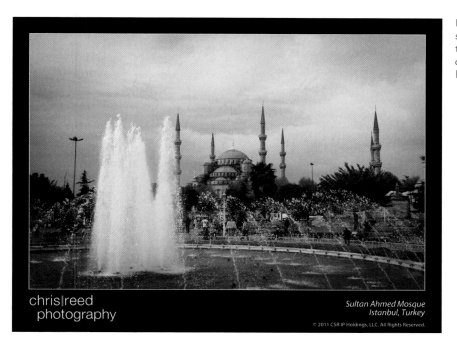

Figure 6.9 The steps in this section will help you create borders that look like these.

Figure 6.10 Set Lightroom to export a full-size JPEG to your hard drive with these settings.

2. In the Post-Process Actions part of the dialog box, expand the LR/ Mogrify list if it isn't already expanded, by clicking the arrow to the left. Then select Outer Borders and click Insert. Select Inner Borders and click Insert again. Repeat the process for Graphical Watermarks and Text Annotations (see **Figure 6.11**). When you're finished, you should see panels for each of the actions you just added in the left-hand side of the Export dialog box.

Figure 6.11 Add the four LR/Mogrify processing actions (outer border, inner border, graphical watermarks, and text annotations) by clicking each one individually and clicking Insert.

3. Scroll to the Mogrify Outer Border Options panel and set the dimensions as shown in **Figure 6.12**. You'll need to make sure that the "Identical borders" box is unchecked unless you want an even border all the way around.

Figure 6.12 Set the outer border options as shown here.

Note

Although I've opted to set a fixed width (in pixels) for each edge, you can also define the border in terms of the size of the image—that is, as a percentage of the image's width, height, short edge, or long edge (see **Figure 6.13**). You can change the color by clicking on the color swatch (which is black in this example).

Figure 6.13 In addition to setting a fixed width, you can also establish the width as a percentage of certain size characteristics of the image.

4. Scroll to the Mogrify Inner Border Options panel and set the dimensions as shown in **Figure 6.14**. This time, make sure that the "Identical borders" box *is* checked (again, unless you want to do something different). Note that you can set both the size and the inset of the stroke and, as with the outer border in Step 3, you can define both in terms of absolute pixels or as a percentage of the image size. Here, I've set a fixed size in pixels. You can change the color by clicking on the swatch (it's white in the example), and adjust the opacity if you desire.

Figure 6.14 Set the inner border options as shown here.

5. Scroll to the Mogrify Graphical Watermarks panel (shown in **Figure 6.15**) and select your logo file by clicking Choose. I've found that PNG files produce the best results. Because we want the logo to be placed on the border, be sure to uncheck the Apply box before outer borders are added. You can place your logo anywhere you like using the Position check boxes; in this example, I placed the logo in the lower-left corner. I configured these settings so that the logo would appear roughly in the middle (horizontally) of the bottom border, but you may need to play around with the insets and logo sizing to get it to appear correctly given the size and shape of your unique logo. Note that I've set a fixed size (on one edge) for my logo in this example, but you can also have LR/Mogrify size it automatically based on the size of your image (see **Figure 6.16**).

Figure 6.15 You may need to play around with the settings in the graphical watermarks to get your logo to appear properly.

Fixed size
Fixed width (auto height)
✓ Fixed height (auto width)
% of image size
% (aspect ratio preserved)
% of width
% of height
% of shortest edge
% of longest edge

Figure 6.16 I've selected a fixed size on one edge in this example, but you should pick the option that works best for you.

6. Scroll to the Mogrify Text Annotations panel (shown in **Figure 6.17**) and add your first text element which, in this example, is the title and location of the image. Because we want the text to appear on the border, uncheck the "Add annotation" box before outer borders are applied. Click Choose next to the Font Name field to pick a font. (The font selector in LR/Mogrify is a little unusual in that instead of giving you a list of installed fonts, it just opens your fonts folder, where you'll have to pick a raw font file.) You can vary the size and color of the font here also.

Figure 6.17 Add your first text element as shown here.

7. Type your text into the "Define your text" box. Although in this example I chose to type in the text, you can also select variables based on your images' metadata by clicking Add Token and then selecting whatever metadata elements you want (see **Figure 6.18**). After typing your text, tell LR/Mogrify where to position it by selecting one of the radio buttons under Position, and setting the horizontal and vertical inset, as shown in **Figure 6.17**.

Figure 6.18 In addition to typing text, you can select metadata variables by clicking the Add Token button, which launches the "Select a token" dialog box.

8. Now it's time to add the second text element, which is the copyright statement in this example. To add a second text element, click the + button at the top of the Mogrify Text Annotations panel. Set the font size, horizontal and vertical inset, and position as shown in **Figure 6.19**, and type in your copyright information in the "Define your text" field (again, you can use metadata variables, just click the Add Token button and select the fields you want).

Figure 6.19 Set
the parameters for
the second text
element as shown
here.

9. When you're finished, save your preset if you like by clicking Add in the Preset section of the Export dialog box and give your preset a name.

10. Click Export and you should end up with an image that looks more or less like the example in **Figure 6.9**.

Once you get the basics down, you should feel free to go back and play around with the various options. LR/Mogrify is incredibly powerful, and with a little effort, you can build an attractive border that not only adds a little security to your images, but also another branding opportunity.

Preventing users from right-clicking on your images

One relatively straightforward technique for limiting access to images posted online is to restrict the right-click functionality of users' computers. There are various ways of doing this depending on the platform that you're using. Many sites, such as the social media services, don't offer you any control over this. Others, like the professional photo marketing platforms, offer specific right-click prevention tools. PhotoShelter, for example, offers a feature where the site automatically applies a transparent layer on top of your images, so if a user attempts to save it using the right-click save-as technique, the user will end up with the transparent layer, rather than the underlying image.

If you're running your own site, you can easily add code that will disable the right-click feature; you can find sample code to do this by doing a simple Internet search. If you're running WordPress, you can find plugins that will do this for you—just search the plugin directory at www.word-press.org/plugins.

Of course, no matter what technique you use to disable the right-click functionality on your website, a nefarious user can always just take a screenshot, which may offer enough size and resolution for the infringer's intended use.

Limiting size and resolution

The only true way to keep full-resolution files out of the hands of image thieves is to not post them at all. Instead, post low-resolution images that aren't particularly useful for anything else.

This approach used to make a lot of sense, but today, high-resolution displays are becoming increasingly popular and many of the websites that you may share your images on are starting to accept full-resolution (or at least very high-resolution) images, which means that lower-resolution images may not be very visually appealing in comparison. Like the other techniques in this chapter, this is one of those areas where you'll need to balance your need for image security against aesthetic considerations.

Where there's a will, there's a way

I've said it before, and it's worth saying again: if people want to steal your images, they'll figure out a way to do it. We'll probably never fully eradicate the image theft problem—all we can do is take reasonable steps to minimize it.

A case in point: several years ago a new college graduate posted an elaborate tutorial on his blog explaining, in painstaking detail, how to defeat the disabled right-click feature and how to remove the "copyright" or "proof" watermark in images posted by the school's graduation photographer. The post was up for over a year and was then removed shortly after photo news blog PetaPixel wrote about it.

Although this particular tutorial is offline for now, the fact remains that for every technique we devise to protect our images, there's someone out there working on a way to defeat it. Always remember the ultimate goal: to maximize lawful access while minimizing unlawful access, understanding that you'll very likely never achieve complete success.

Be reasonable

I sometimes also call this rule "Don't be a jerk." Remember the photographer I mentioned earlier with the three click-through screens before getting to his homepage? Each of the three screens reads like a cease-and-desist letter, warning of stiff fines and criminal prosecution if you use an image from the site without permission. While it's true that there are legal penalties for infringement, the way he presents the information seems a little over-the-top considering it's directed at all users of the site, the majority of whom probably haven't done anything wrong.

People tend to want to help—and do business with—people they can relate to or identify with. If your web presence suggests that you're reasonable and personable, you'll inspire more people to lawfully engage with your work (buy prints, license images, and so on) instead of spending time figuring out ways to steal it.

The music industry learned this the hard way: In the late 1990s and early 2000s, when the music file sharing sites were rampant, the recording industry famously brought lawsuits against individuals who had downloaded music illegally. Although many of the recording industry's targets were repeat offenders, there were also a lot of college students, grandmothers, and other sympathetic defendants who had just downloaded a song or two. Although a sympathetic defendant doesn't make the underlying conduct any less illegal, the lawsuits made the recording industry look heartless and prompted a backlash that still haunts the industry to this day.

Bottom line: like the adage about catching more flies with honey than vinegar, having a little empathy for your potential customers, rather than treating them like criminals at the outset, can go a long way toward engendering support, respect, and hopefully repeat business.

Other Considerations

Beyond the core principles, there are several things you'll want to keep in mind when posting your copyrighted images to the web. These issues, discussed in this section, include understanding the terms and conditions of web services that you use to share and store your images, as well as the way those services deal with your metadata. I also discuss a relatively new licensing regime that's starting to take off online called Creative Commons.

Terms of service

The terms of service of a particular website are essentially the contract between the website and its users. Among the most important clauses in the terms of service for photographers are the ones that deal with copyright: who owns the copyright to the content you post on the site, and what the website is allowed to do with it. These clauses very often provide that you retain the copyright in anything that you post, but also require that you grant the website very broad permission to use that content. For example, one social media site's terms of service say that the site "does not claim ownership of any content that you post," but that you grant the website a "nonexclusive, fully paid and royalty-free, transferable, sublicensable, worldwide license to use the content that you post."

Why do websites need such broad licenses to your images? There are two main reasons. The first, and most technical, is that most big commercial websites do not connect directly to their end-users. Instead, they channel the site's content through various intermediaries such as content delivery networks. The broad license ensures that the website has the rights necessary to authorize the intermediaries to distribute the website's overall content, including your images. In short, the website needs these rights to make the website work (in fact, some of the more responsible terms of service out there limit the copyright license to apply "solely in connection with the operation of the website" or something along those lines). The second reason is slightly more cynical, but just as legitimate: the bottom line is that these terms of service are drafted by lawyers whose primary job is to minimize the chances that the website will get sued, and having very broad rights is one way to do that.

Despite these legitimate business reasons, a number of photographers and photographer advocates are skeptical about websites' ultimate intentions. Some have asserted, for example, that the terms are often so broad that they could permit a website to use user-contributed images in marketing and promotional materials—a use that would typically be licensed separately—without compensating the photographer. Worse, some have suggested that a website might launch its own stock photo service, licensing user-contributed images to third parties, again without compensating the photographers.

Though these extreme scenarios might be technically permissible under common terms of service provisions, they're highly unlikely. For one, the companies that run social media sites, cloud storage sites, photo hosting sites, and so on aren't in the business of licensing images—it's an entirely separate and unrelated industry, and just because the terms of use technically grant them the right to do it, doesn't mean they will. In addition, the negative PR ramifications of doing something like that would almost

certainly lead most companies not to ever try it. That's not to say it's impossible, but it seems very, very unlikely.

A more practical concern is that by granting a website such broad rights to your images, you might preclude your ability to grant exclusive licenses to those images down the road. Depending on the circumstances, though, this is the sort of thing that you may be able to negotiate around. I have a clause in my agreements, for example, that provides exclusivity in a particular context (such as a particular industry or a particular medium), subject to my own use for marketing and promotional uses (including social media). That allows me to post images to popular social media sites but still enter into exclusive licensing arrangements.

One thing to keep in mind about terms of service agreements is that they can change frequently, so be sure to keep your eye out for messages from the sites you share your work on about updates or changes to their terms that might affect you. Often these messages take the form of a pop-up notice that appears when you log into the site, or an email sent to the registered address of each user. Typically, if you continue to use the site following such a message, you're deemed to have accepted the new terms.

Another feature of terms of service agreements to be aware of is that very often the license grant survives the termination of the agreement. That means that even if you cancel your subscription, close your account, or otherwise stop using the website, the site's license to keep distributing the content you've already submitted continues. That's not always the case, and it's not always that cut and dried, but you should be aware that there are some circumstances where even after you terminate an account, the website may still be permitted to do certain things with your work.

Photo competitions: Read the terms of service before you enter

Many of the considerations about terms of service apply equally to terms and conditions of photo competitions. Although there are numerous reputable contests you can enter, there are also dozens of more nefarious contests that often include significant "rights grabs" as a condition of entry—either total assignment of the copyright or unreasonably broad usage terms, for photos entered into the competition. You shouldn't let this put you off from entering contests, but you'll want to take a close look at the terms of entry before deciding which contests to particpate in.

One resource that might be helpful as you evaluate which competitions are right for you is PhotoShelter's The Photographer's Guide to Photo Contests, which is available free (whether you're a PhotoShelter subscriber or not) at www.photoshelter.com/resources.

Like everything else in this chapter, how you ultimately handle your social media presence, and what level of risk you're willing to take with your images depends on your own goals. I've deliberately avoided delving into any particular service's terms because the goal of this section is not to tell you which services you should and shouldn't use, but instead, to help you understand the principles that underlie terms of service agreements, and the practical impacts associated with them, so you can make the best decisions given your own circumstances.

Metadata issues

One unfortunate characteristic of many web-based distribution platforms is that they often strip out the metadata of uploaded images. It's unclear why they do this—I've heard that privacy may be a factor, which makes some sense, although it doesn't explain why they would remove critical information about the image's copyright.

The International Press Telecommunications Council (the organization that developed the IPTC standard for photographic metadata) recently conducted a study of the major social media sites and concluded that many remove key metadata elements without notice to the photographer. The problem is not only that the photographer's name and copyright information are not displayed on the website in question, but more important, that it's stripped out of the image file itself. So, for example, if you save one of my images from Facebook using the right-click save-as technique, you'll capture the image file but none of the metadata I included (see Chapter 2 for a discussion of the metadata you should consider adding to your work) which essentially creates an orphan work (see Chapter 1). Because sites change their practices regularly, you should check out the latest version of the metadata tests by visiting www.embeddedmetadata.org.

Unfortunately, short of not posting images to the web, there isn't much you can do about this, except continue to put pressure on the websites to change their practices. One workaround is to be sure to include watermarks or image borders on images that you plan to post on social media sites that strip out metadata. Although not perfect, it goes a little further to help keep your name and copyright information attached to the image.

Creative Commons

Creative Commons (CC) is a foundation that has developed a series of standardized licenses that are designed to make it easier for copyright owners to broadly share their works and allow people to do certain,

defined things with those works. A number of popular photo sharing sites allow you to designate images as being available under a CC license, and it can be easy to accidentally check the CC box, so it's important you understand what it means.

One example is the CC Attribution license, which allows users to distribute, remix, or build upon your work (even for commercial purposes), so long as the original copyright owner is credited. Another example is the Attribution-NonCommercial-ShareAlike license, which allows users to distribute, remix, or build upon your underlying work, so long as it's only for noncommercial purposes, the original copyright owner is credited, and the user licenses his or her new work under the same terms. You can often identify works licensed under a CC license because instead of the © icon, you'll see a "CC" followed by the phrase "Some rights reserved."

A number of photographers and advocates of photographers' rights have vocally denounced CC as being "anti-copyright" or somehow weakening the rights of copyright owners, but nothing could be further from the truth. Because CC licenses are just that—copyright licenses—the whole scheme requires a well-functioning copyright system to work. In Creative Commons's own words, "CC licenses are not an alternative to copyright. They work alongside copyright and enable you to modify your copyright terms to best suit your needs."

One very important caveat to note about CC licenses is that they are irrevocable, which means once you decide to license a copyrighted work, such as a particular image, under a CC license, you can't change your mind. So, for example, if you release an image under the Attribution-NonCommercial-ShareAlike license discussed earlier, and I take that image, comply with the license terms, and make your image available on my website, there's nothing you can do about it even if you decide to stop making that image available yourself. I should note that some copyright experts question whether the irrevocability of CC licenses is enforceable, but until that issue gets settled, assume that it is and that once your work is out under a CC license, it'll always be under a CC license.

So, should you ever use a CC license? If you intend to monetize your images, probably not, because the value of your images will be reduced by the potential widespread availability of the same image under a CC license. But the answer really is, "It depends"—on your goals, your business model, and how much control you want to maintain over your work. Trey Ratcliff, a well-known photographer and educator releases most of his images (in full resolution!) under a CC license that requires attribution and limits uses to noncommercial purposes, but he separately licenses commercial uses and also uses his images as a platform for other revenue-generating activities such as selling prints, books, workshops, and other

related products and services. Similarly, I recently saw a photographer release a set of bracketed exposures under a CC license and actively encourage people to download them and create their own tone-mapped HDR images from them as a way to generate interest in his own HDR work, which he makes available under more traditional licensing terms.

Will these models work for you? Maybe. Again, you have to think through your own goals and objectives and come to a decision that makes sense for you and your images. Despite how CC licensing sometimes gets characterized, it's not an all-or-nothing decision. You might choose to release some images under a CC license while retaining the bulk of your catalog for traditional rights-managed licensing. Only you—in consultation with your legal and financial advisors—can make that decision. What's important is to make sure that you fully educate yourself on the options so you understand the landscape before wading in.

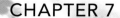

CHAPTER 7

Monitoring and Enforcement

So far, this book has guided you through building a workflow that will help you protect and manage your digital image copyrights from capture through sharing them online. As I've written before, the odds are pretty good that if your work is online, at some point it'll get used in a way that you didn't intend—that's just an unfortunate reality of the Internet age. This chapter explains your options when it happens and helps you start to develop your own copyright enforcement strategy to deal with infringers.

Broadly, *copyright enforcement* refers to the idea of stopping people from using your work unlawfully. Notice that I didn't say "without permission." There are some limited situations where someone might be able to use your copyrighted work without permission, and it's completely legal to do so, such as in situations where there is a fair use (see Chapter 1). But the cases where fair use (or other limitations and exceptions to copyright) apply are generally pretty rare, and in the vast majority of cases, you'll find that someone using your image without permission is doing so illegally. That's especially true on the Internet, where the majority of infringements involve something along the lines of someone taking an image from a photographer's website and using it in a blog post, on a social media site, or worse, posting it to his or her own website and claiming it as his or her own work (believe it or not, it happens!).

This chapter first walks through how to identify and track unauthorized uses and then provides some guidance on your options when you find them.

 CAUTION!

Perhaps more than any other area of this book, how to proceed when you identify an infringement can have very significant impacts on your rights down the road. Although this chapter provides you with a general overview of the options available in the event your images are used without permission, I strongly encourage you to consider speaking with a lawyer to develop an overall enforcement strategy and a plan of attack for those cases when you find people infringing your work. That's not to suggest you'll necessarily need a lawyer in each and every case of infringement that comes up, but consulting with a lawyer early on about the circumstances in which you can handle infringement issues yourself versus when you should involve a lawyer can be very helpful and save you a lot of time, money, and possible anguish down the road.

You've probably heard the phrase "anything you say can be used against you" on TV and in the movies when people get arrested. Well, that same principle is true in copyright litigation as well, at least to a degree. Almost anything you say or write to an infringer might be used against you later in court, so it's very important to get it right, and working with a lawyer to set up the process will help you do just that.

Identifying Unauthorized Uses

The first step in enforcing your copyrights is a fairly obvious one: you need to identify the people using your work unlawfully. It's been my experience that most photographers stumble across infringements on their own, or someone close to the photographer—a friend, family member, or fan—will alert the photographer to the unauthorized use. Of course, this sort of natural discovery process is not particularly comprehensive, so if you're looking for something that's a little more structured, you might want to consider one of the various image search or tracking services that are available online.

Services such as TinEye (www.tineye.com) and Google Reverse Image Search (go to https://support.google.com/websearch/answer/1325808 for instructions) are search tools that allow you to upload your images and receive a list of websites where that same image appears. This is, of course, a very manual process and may work well if you're interested in seeing where one or a small handful of images from your catalog has ended up, but for larger-scale operations, using an image search engine is probably a bit too laborious. One other downside to image search engines is that they're only able to return results that appear in the portion of the web that they've indexed. Granted, that's a lot of the web, but it's not everything, and more recent uses in particular may not appear right away in search results (just like a regular text search).

Beyond image search engines there are commercial providers that, for a fee, offer various tracking and monitoring tools that proactively scour the Internet and generate reports that indicate where your images are being used. One such offering is the Digimarc Search Service (www.digimarc.com), from the same providers of the Digimarc watermarking technology that I described in Chapter 6. A similar service is ImageRights (www.imagerights.com), which offers not only image tracking and monitoring tools, but also enforcement services to help pursue infringers through copyright lawyers with which ImageRights has established relationships. A company called PicScout (www.picscout.com), which is owned by Getty Images, offers similar services through its own image fingerprinting technology and a host of services designed to help content owners monetize their works online (though it's mostly aimed at larger-scale operators, such as stock agencies, as opposed to individual photographers).

Dealing with Unauthorized Use

Once you've identified a particular instance of apparent infringement, you have several options for dealing with it, which I discuss in this section.

Notice and takedown

Notice and takedown is a shorthand slang term that refers to a procedure described in the Digital Millennium Copyright Act (DMCA), where copyright owners (or their designated agents) can issue an online service provider a "notification of claimed infringement" (more commonly called a "takedown notice," though that's not the technical legal term) asking the provider to remove the infringing content. The procedure applies only to content that's uploaded by users of service providers, not content produced by the service provider itself, and the definition of an online service provider for purposes of the DMCA is pretty broad; it includes hosting companies, as well as companies that operate more elaborate platforms, such as social media or other content sharing sites. In exchange for taking down infringing material quickly (and for playing by some other rules in the DMCA), the law says that you can't sue the service provider for copyright infringement.

So, for example, if someone infringes on your work by uploading it to Facebook, you can use a takedown notice to ask Facebook to remove the material. Similarly, if I were to illegally post one of your images on my blog, you could use the notice and takedown procedure to ask my hosting company to remove the infringing content (but you wouldn't use this procedure to ask *me* to take it down, since I'm not the service provider).

Unfortunately, despite its apparent simplicity, the notice and takedown procedure has become the source of lots of frustration and, in some cases, high-stakes litigation. You have to jump through a number of procedural hoops to make sure the takedown notices are legally effective. What's worse, the law has developed such that even when a service provider is made aware of an infringement, all it's required to do is take down *that specific infringing copy* of the copyrighted work, regardless of whether there are other infringing copies on the site or whether new copies are uploaded as soon as the old ones are taken down. Some websites have implemented filtering technologies so that they can immediately identify certain clearly copyrighted content (like commercial movies or songs) and prevent them from being posted in the first place (or allow them to be posted but only on terms established cooperatively between the website and the copyright owner), but the law doesn't require them to do that.

Most copyright owners agree that the notice and takedown system as it currently stands is largely ineffective. Intellectual property scholar Bruce Boyden observed that "mainstream copyright owners now send takedown notices for more than 6.5 million infringing files, on over 30,000 sites, each month," and that ultimately, "despite all the notice, there is precious little 'takedown' to show for it. Unless a site employs some sort of content filtering technology, the same content typically re-appears within hours after it is removed." While that's a challenge for big copyright owners, like book publishers and movie studios, it's an even bigger one for independent creators, like photographers, who often lack the resources to mount large-scale notice-sending operations.

Stakeholders have identified the ineffective notice and takedown system as a potential area for reform if Congress ultimately updates the copyright law (see the Introduction for a brief discussion about proposed updates to the copyright law), but until that happens, we're stuck with the current system. Although it may not work particularly well, it's still one potential avenue for enforcement. In the rest of this section, I provide some guidance on how to issue a proper takedown notice.

How to issue a takedown notice

The law requires that a takedown notice meet certain specifications to be legally enforceable. If you don't follow the directions and include the required information, the service provider can ignore it. Here's what the law says you have to include:

- A physical or electronic signature of the copyright owner, or someone authorized to act on the copyright owner's behalf.

- Identification of the copyrighted work that is being infringed, or a "representative list" of works if you're issuing a single notice that covers multiple works. This might be a list of your images and their respective registration numbers, or a link to your website where you've posted legal versions of the works. Generally, just try to include as much detail as possible about the work(s) that you own the copyright to.

- Identification of the material that you want taken down. This is where you describe where you found the infringing material so that the service provider knows what to remove. You should be as detailed as possible here to avoid the service provider arguing that it couldn't take down the material because it couldn't find it.

- Your contact information so the service provider knows how to reach you. The law specifically suggests an address, telephone number, and email address, and I suggest providing all three.

- A statement that you have "a good faith belief that the use of the material in the manner complained of is not authorized by the copyright owner, its agent, or the law."

- A statement that "the information in the notification is accurate, and under penalty of perjury, that the complaining party is authorized to act on behalf of the owner of an exclusive right that is allegedly infringed."

 CAUTION!

Pay particular attention to the last two items. Not only must a takedown notice include the quoted language exactly as it appears (it's quoted because that's how it appears in the law), but you must actually have a good faith belief that the material you want taken down is infringing, you must be certain that the information in the notice is accurate, and you must be the copyright owner or authorized to act on the owner's behalf. If any of these is untrue and you issue a takedown notice anyway, you could end up getting sued yourself, because making misrepresentations in a takedown notice is a violation of the DMCA. That means you need to be very careful to ensure that the person who posted the image you're looking to have taken down doesn't somehow have a license to use the image. For example, I probably wouldn't want to issue a takedown notice for one of my images that I've licensed through a microstock agency because I have no idea who has licensed the image and can therefore make lawful use of it (unless, of course, I see a use that exceeds the scope of the license that I've authorized the stock agency to offer). Everyone's circumstances will be a little different here, but the key is to remember that you should never issue a takedown notice unless you're sure that your work is being infringed.

So, who do you send your notice to? That depends on what kind of service you're going after. If the infringing content is on, say, a social media site, then the operator is likely fairly apparent (for example, it's relatively easy to figure out that www.facebook.com is operated by Facebook, Inc.), but for other sites, such as personal websites, you'll have to figure out who the service provider is (for example, the hosting company), which can be a little bit tricky. The best way—which is not always perfect—is to use a whois service such as the one run by Network Solutions (www.networksolutions.com/whois/index.jsp) that will allow you to type in the domain name of the site that's hosting your infringing content and find the domain registry and, in many cases, the hosting service.

Once you have the name of the service provider that you're after, you'll need to figure out specifically who to send the notice to. Part of the deal that the law strikes with online service providers is that in exchange for the safe harbor described above, they have to designate a specific person (either by name or title) to receive the takedown notices and file that information with the Copyright Office, which maintains a database of agents (www.copyright.gov/onlinesp). The law also requires that a service provider disclose the name and contact information of its designated agent on its website. It's not always immediately apparent where it is and you may have to do a little hunting for it, but most websites include it in their terms of service, so check there first.

Unfortunately, there is no requirement that service providers follow up with you to confirm they've removed the infringing content, and in many cases, some particularly bad sites just ignore them, assuming (safely in most cases) that the copyright owner won't ever come after them or the user who's ultimately infringing on the copyrighted work.

> **Tip**
>
> Many of the large service providers offer online takedown portals that allow you to comply with the requirements of a DMCA takedown notice without having to send a hard copy. These web forms are usually fairly straightforward, but finding the right one to use is sometimes tricky because many services have multiple forms depending on which part of the service is hosting the infringing content. Google, for example, has separate takedown procedures for Google Plus, Google Play, Blogger, Google Ads, and the search engine. Before preparing a formal written takedown notice, you might want to search the service that's hosting the offending content to see if it offers such a tool.

Counter notices

Earlier in this chapter, I suggested that a service provider has an obligation to take down infringing material when it receives a takedown notice. That's generally the case, but there's a little more to the story. The

notice-and-takedown procedure described in the preceding section also gives the alleged infringer—the person who uploaded the content that you had taken down—an opportunity to respond through what's called a *counter notification* (or sometimes just a *counter notice*). In essence, while your takedown notice essentially says, "This content is infringing; take it down," the counter notice says, "It's not infringing; put it back up." A common reason why someone might issue a counter notice is if he or she believes that it was a fair use of your copyrighted work (see Chapter 1 for a more in-depth discussion of fair use).

When a service provider receives a counter notice, the law requires that it provide a copy to the copyright owner (or its agent—whoever issued the takedown notice) who must then bring suit in federal court to obtain a court order to keep the material from going back online. If the copyright owner doesn't respond within 14 days to the counter notice, the service provider must put back the material that it took down as a result of the original notice.

Counter notices are not unheard of, but they're also relatively rare. To illustrate, using data supplied by the Motion Picture Association of America (MPAA), a trade association made up of the major Hollywood film studios, Professor Bruce Boyden found that during a six-month period in

The Chilling Effects Clearinghouse

You should be aware of the Chilling Effects Clearinghouse (www.chillingeffects.org), which, in its words, monitors "the legal climate for Internet activity," by cataloging DMCA takedown notices and cease and desist letters issued by copyright owners and making the full text of those notices—often including the sender's contact information—available online for anyone to see. While most of the notices indexed on the site were issued by large content companies or their trade associations, the site also catalogs notices issued by individual creators.

Sandra Aistars, the executive director of the Copyright Alliance, a nonprofit organization representing the interests of creators, recently said in a statement submitted to Congress, that "the site unfairly maligns artists and creators using the legal process created by [the DMCA] as proponents of censorship" and observed that "because the site does not redact information about the infringing URLs identified in the notices, it has effectively become the largest repository of URLs hosting infringing content on the Internet."

I leave it to you to decide what you think about the Chilling Effects Clearinghouse, but before sending a takedown notice (or a cease and desist letter, which is the subject of the next section), you should at least be aware that the site exists and that there's a possibility that your notice or letter will end up there for the world to see.

2013, MPAA members issued 25.2 million notices to various online service providers, and received just eight counter notices. That suggests not only that most infringing users are well aware that they're engaged in unlawful infringement, but also that copyright owners are not abusing the notice and takedown system, as its critics often assert.

Cease and desist letters

The notice and takedown procedure pertains to getting infringing content off of service providers—the notices you send under that procedure go to the operators of such service providers as opposed to the individuals who uploaded the content. In this section, I discuss a more general enforcement technique that may be helpful in enforcing your rights against the individuals or companies that are engaged in the actual infringement of your work: a cease and desist letter (often referred to as a *C&D letter* or just a *C&D* for short). Unlike the notice and takedown procedure, which is governed by very specific guidelines in the law, a cease and desist letter is really nothing more than a letter asking an infringer to knock it off.

Probably the biggest challenge in sending a C&D is figuring out who to send it to. Some reputable businesses will have contact information on their websites, but many are very difficult to track down. You can use the whois tool described earlier to find the owner of a website, but these days many people register domain names privately, making it difficult to find out who's actually behind a particular site. You can email a C&D (again, there are really no legal requirements), but then you have no way of knowing whether it was actually received, whereas if you mail it or send it via an express delivery service, you can obtain tracking information.

A C&D typically contains similar elements to a takedown notice under the DMCA, but unlike a formal notice, you don't need to include the formal "good faith belief" representations. You'll want to make sure to clearly describe the copyrighted work that you own and how it has been infringed, and ask the infringer to cease and desist from continuing the infringing conduct.

The tone for these letters is polite but firm. Try to avoid using incendiary language and simply state the facts of the infringement and respectfully demand that it stop. Writing a nasty letter might make you feel better, but it could hurt you in the long run. If you end up in court, there is a very real likelihood that the letter will become part of the record, meaning the judge (or possibly a jury) could see it, so you want to make sure that you come off as reasonable. One company I worked for always included language in its C&Ds that said something to the effect of "we understand that the infringement was very likely inadvertent," whether or not it actually did seem inadvertent. The goal is to get the infringer to stop.

 CAUTION!

This is another one of those areas where it may be beneficial to speak with a lawyer to help you develop standard language for your C&D letters. Oftentimes C&Ds include language that reserves certain rights, or threatens certain legal actions, and you want to be sure that you include (or don't include) certain things based on your particular circumstances and the law of your jurisdiction. Once you have a template down, you can probably handle C&Ds by yourself, but getting a lawyer to set you up on the right path will save you a lot of time, money, and potential heartache down the road.

Tip

Somewhat paradoxically, a good place to see what C&Ds look like (and DMCA takedown notices, for that matter) is *www.chillingeffects.org*, because it catalogs a wide array of such letters and notices from a variety of different copyright owners.

Unfortunately, in practice it's fairly rare for a C&D to successfully stop instances of ongoing infringement. In some cases, the infringer may respond claiming that it isn't infringing, but the more likely outcome is that your letter will simply be ignored. In some cases, at this point, depending on the circumstances surrounding the infringement, you may want to take things to the next level by pursuing litigation.

Litigation

Litigation is the general term that refers to the process of suing someone or some entity. Broadly, litigation is expensive, time consuming, and for many individual copyright owners (as opposed to big companies), very emotional, but sometimes it's the only way to fully enforce your rights.

Available relief

Copyright law provides for two different remedies for copyright infringement: *damages* (money) and *injunctions* (court orders that tell the infringer to stop infringing). As I explain in Chapter 1, copyright law has two different types of damages: actual damages and statutory damages. Actual damages can include your actual losses and the infringer's profits attributable to the infringement, but they're often very difficult to prove. That's why the law also provides for statutory damages, which allows the court to grant an award within a range, between $750 and $150,000 per work

infringed. Courts are empowered to grant awards as low as $200 if the court determines that the infringer "was not aware and had no reason to believe that his or her acts constituted an infringement of copyright." You can minimize the chances that an infringer can make this so-called "innocent infringer" argument by following some of the techniques in this book, such as making sure your work is registered, putting copyright notices on your website, and so on.

Courts are also empowered, but not required, to award the prevailing party (which could be either side, not necessarily the person who brings the suit in the first place) with court costs and attorney fees associated with bringing the case.

But keep in mind that statutory damages, costs, and attorney fees are only available if the work that is the subject of the litigation was registered before the infringement or within three months of publication. That's why it pays to register your work as soon as possible with the Copyright Office (see Chapters 2, 3, and 4 for how to do that). Many attorneys won't take cases that aren't likely to qualify for statutory damages because the prospect of ever making any money off the case is so low. Registration is also important simply because it's required to file a lawsuit. Courts can't take copyright cases unless the work is first registered (regardless of whether the work is registered before the infringement or within three months of publication).

Where to file suit

In the United States, copyright law is almost entirely federal (as opposed to state law) and copyright cases are heard in federal courts. Each state has at least one federal court, and most states have more than one (for example, New York is divided into four separate districts: the Southern, Eastern, Western, and Northern districts). Where you bring your lawsuit has to do with some rather complicated jurisdictional questions relating to where you are, where the defendant is, where each of you do business (if it's different from where you reside), and where the claim arose. In larger cases, there is also some strategy involved, because certain districts are known for having faster dockets or for having experience with the technical nuance of copyright law. For example, the Southern District of New York tends to hear a lot of copyright cases because of the heavy presence of the publishing and media industries in New York City, which is part of that judicial district.

Which judicial district to bring a case in is one of the first and most important decisions you can make in the litigation process, and it's another reason why it pays to talk to a lawyer earlier rather than later if you're thinking about filing an infringement lawsuit.

Injunctions are relatively straightforward and simply order the infringer to stop engaging in infringement. In cases of blatant infringement, such injunctions typically require that the infringer stop immediately. In circumstances where the infringer may not have realized it was infringing, or perhaps incorporated the work that was infringed upon, not a larger work (for example, an image that appears in a TV documentary), as opposed to a blatantly unlawful reproduction, the injunction might give the infringer a bit more flexibility.

What you have to prove

In very general terms, to prove that the defendant infringed your copyright, you'll have to show the court (either the judge or jury, depending on how the case proceeds) that:

- You own a valid copyright.

- The defendant had access to the work.

- The alleged infringing copy is substantially similar to your work.

If you're seeking monetary damages and aren't eligible for statutory damages (because the work wasn't registered in time), you'll also have to prove how much money you lost as a result of the infringement or how much the infringer gained.

Demonstrating that you own a valid copyright is easy if you follow the steps in this book, because your registration certificate is deemed to constitute evidence of a valid copyright. That's not to say that the other side might not question it (see the next section for a more in-depth discussion of defenses), but when you show up to court with a certificate, it shifts the burden to the defendant to show that your copyright isn't valid.

Proving access is usually also fairly straightforward, especially today in the photography business, where work is typically distributed online. Access becomes a little trickier when there are allegations of infringement relating to unpublished work, but generally speaking, copyright cases rarely turn on whether the defendant had access.

The notion of "substantial similarity" is a little messy. Unfortunately, different courts have interpreted it differently, and as a result, there are a number of ways that courts think about it. Some courts use the "total concept and feel" test, which requires the judge or jury to consider the works taken as a whole, while others use a "filtration" test, where the court removes (filters out) the parts of the underlying works that are not copyrightable and considers only whether the copyrightable parts of the works are substantially similar.

Why does it matter what region you're in?

Earlier in this chapter, I explain that copyright law is almost entirely federal, so you might be wondering why the test for infringement varies depending on what region of the country you're in. Although the copyright statute—the actual law passed by Congress and signed by the president—is applicable to the entire country, it has been interpreted in slightly different ways by courts in different parts of the country. In addition to the local judicial districts I cover earlier, the country is divided into several bigger judicial regions called *circuits*. There are 13 circuits, 12 of which are defined by geographic boundaries, and one of which is dedicated to certain types of cases. Each circuit has one court of appeals, which hears appeals from the trial courts within that circuit. So, for example, if I'm dissatisfied with the result of a lawsuit I brought in the Southern District of New York, I would typically appeal it to the Court of Appeals for the Second Circuit, because the Southern District of New York is located within the Second Circuit.

The interpretations made by each circuit court of appeal are binding on the trial courts (the district courts) within that circuit. So, for example, the Southern District of New York is required to use the substantial similarity test that is followed by the Second Circuit, but the Central District of California is required to use the test followed by the Ninth Circuit. As a result, it's possible to have different results in similar cases brought in different parts of the country. These situations are sometimes called *circuit splits*. The existence of a circuit split is often thought to be a major consideration of the Supreme Court in deciding whether to accept a case, since a decision from the Supreme Court would be binding on all the appellate and district courts below it.

If this sounds a little confusing, that's because it is. To make matters even more complicated, each of these two tests has variations, which I won't get into here, and some courts have even recognized the existence of other tests of substantial similarity. This is, again, one of those areas where your lawyer will be immensely helpful, because he or she will know what tests are used in what part of the country and how best to proceed with your case, given the facts at hand.

Defenses

Of course, most defendants don't go down without a fight. For every accusation you might make against an infringer, there will almost certainly be a defense. Here's a quick summary of some of the more common copyright infringement defenses:

- **You waited too long to sue.** Like many laws, copyright law contains a statute of limitations that requires that you bring suit within a certain period of time. For copyright claims, you're required to file suit no later than three years after learning of the infringement.

- **The copyright is invalid.** This isn't that common, because the range of copyrightable subject matter is so broad, but it can happen. For example, if you were claiming that someone infringed a pattern you created, but it turns out the pattern was actually something you found in nature, the validity of your copyright might be called into question. The theory is, if you don't own a valid copyright, the defendant can't have infringed it.

- **The registration is invalid.** This is more common than asserting that the copyright is invalid. You don't need to register the copyright to have a valid, enforceable copyright, but your registration (and the timeliness of that registration) is the key to statutory damages and attorney fees, which makes the potential downside to losing a copyright case particularly dangerous for a defendant. Because of that, most defendants will work hard to defeat your registration, perhaps claiming you misrepresented material facts on the application or didn't properly disclose certain features of the work you registered. If the defendant can defeat the registration, you won't be entitled to statutory damages or attorney fees and, the thinking is, might even walk away from the rest of the case, since your prospect of recovering anything is reduced significantly.

- **The defendant created it independently.** Interestingly, it's not an infringement of your copyright if I come up with a substantially similar work all on my own, without copying your original. With this defense, the defendant is essentially saying, "Yes, our works might be substantially similar, but I created mine independently." This typically arises where there are questions as to whether the defendant had access to the work that he or she allegedly infringed.

- **The use was permissible under some limitation or exception.** The copyright law includes a number of limitations and exceptions to the exclusive rights of copyright owners (see Chapter 1). So, often if you make an accusation that someone infringed, a logical response is that it was permissible under the Copyright Act because of one of those limitations. The most commonly asserted defense in this regard is fair use, which essentially means the infringer is acknowledging that he or she made an unauthorized use, but that it was non-infringing because it's permitted by the fair use doctrine.

- **The use was permissible under a license.** Sometimes a copyright dispute boils down to the scope of a license agreement, where the defendant asserts that it had a license to use the copyrighted work,

and the copyright owner asserts that it exceeded the scope of the license (or in other words, went further than the license allowed). This came up recently in a fairly high-profile case involving a textbook publisher that had licensed images from a stock agency for a print run of a certain number of copies. The assertion in the lawsuit was that the publisher had routinely exceeded the number of copies it was authorized to make under the terms of the license, rendering the excess copies infringing.

Notice that merely being unaware that a particular work is copyrighted, or that a particular use constitutes infringement, are not defenses. A court might take those factors into account during the damages phase of a copyright case, but for purposes of establishing liability, those arguments are irrelevant.

Judgments

Winning a lawsuit is really only the first step in recovering from an infringer. The second step is arguably the harder of the two: collecting the money (assuming you sought and received a damages award). You've probably heard the axiom "You can't get blood from a stone," and that's certainly true in litigation. Just because a court determines that someone must pay you some amount in damages doesn't mean that you'll ever be able to collect it because, in many cases, the person or entity simply doesn't have it. An individual or company might file for bankruptcy and find the debt discharged, or a company might simply close up shop. Unfortunately, there isn't much you can do about that—it's just one of the realities of litigation that you'll have to take into consideration when deciding whether to pursue a lawsuit in your particular circumstances.

"Small" copyright claims

Litigation in federal court is expensive and time consuming, and for independent creators (or even small businesses), using the system to redress infringement can be cost prohibitive and simply not worth the time—time you're spending on the litigation is time you're not spending running your business. Recognizing this as a major challenge for the copyright system, the Copyright Office recently issued a proposal for a small claims tribunal within the office itself that would essentially serve as a small claims court for copyright claims valued at up to $30,000. Although the creation of such a system is likely a long way off, the fact that both the Copyright Office and Congress have expressed awareness of this issue, and demonstrated an interest in potential solutions, is a major step in the right direction. You can read the Copyright Office's full analysis and proposal at www.copyright.gov/docs/smallclaims/usco-smallcopyrightclaims.pdf.

Pulling It All Together

The last six chapters have offered a detailed walkthrough of a workflow for protecting, managing, and sharing your digital images: from pre-shoot considerations (Chapter 2) to the registration process (Chapters 3 and 4) and records management (Chapter 5), through best practices for sharing and distributing your images (Chapter 6) and monitoring use of your work and enforcing your copyrights, if it becomes necessary (Chapter 7). This chapter ties everything together so you can see how the material you learned throughout this book can be incorporated into your image processing workflow.

The idea of a "workflow" tends to suggest that the process is a one-way street, with a beginning, a middle, and an end. Though that's more or less true for any particular set of images, from a daily practice perspective, the steps in this book really come together to form a cycle that becomes a part of your everyday photography routine.

The workflow cycle can be broken down into three distinct phases (see **Figure 8.1**):

1. Planning and setup

2. Registration and records management

3. Sharing and monitoring

Each phase contains several of the steps discussed in this book. The remainder of this chapter walks through each of the phases and lists the major steps in each one. You can use this as a checklist as you work through building these concepts into your own workflow.

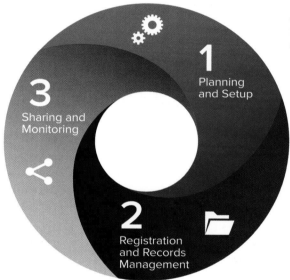

Figure 8.1 The full workflow described in this book forms a cycle.

Copyright Workflow for Photographers

Phase 1: Planning and Setup

The Planning and Setup phase (shown in **Figure 8.2**) is where you lay the copyright foundation for your entire workflow. It begins before you even start shooting:

1. Set the copyright metadata parameters in your camera(s), if supported (Chapter 2).

2. Set up Adobe Lightroom import presets that include your copyright information, as appropriate (Chapter 2).

> **Note**
>
> You may have different presets for different types of work, depending on who the copyright owner is or the copyright status of the work.

3. Determine your registration strategy: single image, shoot-by-shoot, or periodic (Chapter 2).

Figure 8.2
The Planning and Setup phase.

Phase 2: Registration and Records Management

Phase 2 (**Figure 8.3**) starts when you have an image, or a batch of images, that you need to process. This phase is about registering your work with the Copyright Office, maintaining your own copyright records, and updating the public record, as necessary:

1. Capture your images.

2. Import your images into Lightroom or whatever image management tool you use.

3. Register your images with the U.S. Copyright Office.

If you're registering a batch of images, figure out if they're published or unpublished (Chapter 2). If they're all unpublished, you can file an application to register an unpublished collection electronically using eCO (Chapter 3).

If they're all published, you can file an application to register a published group of images using paper Form VA (Chapter 4).

> **Note**
>
> If you have a mix of published and unpublished images, you'll need to separate them and register the published images separately from the unpublished ones.

If your application for registration is refused, determine whether you want to file a request for reconsideration, if applicable (Chapter 5).

4. Maintain records of your copyright registration.

 If your application for registration is granted, and you receive a certificate, update your Lightroom catalog with the registration number issued by the Copyright Office (Chapter 5).

5. Keep your copyright registration up to date.

 If you need to make corrections or clarifications to your registration record (the information on the certificate), file Form CA with the Copyright Office (Chapter 5).

 Record pertinent documents (licenses, transfers, and so on) with the Copyright Office to ensure that the public record remains properly updated and accurate (Chapter 5).

Figure 8.3 The Registration and Records Management phase.

1 Image Capture
2 Image Import
3 Image Registration
4 Maintain Records
5 Update Registration

Phase 3: Sharing and Monitoring

With the Registration and Records Management phase of the workflow completed, you can turn your attention to sharing your work and monitoring for unauthorized use, which is the third and final phase of the workflow (see **Figure 8.4**):

1. Establish your goals for distributing your images (for commercial purposes, sharing with friends and family, and so on) (Chapter 6).

2. Based on your goals, select the venue(s) in which you want to share your images (such as social media sites, your own blog, a commercial image-hosting service, and so on) (Chapter 6).

3. Apply image security as desired, which may vary by venue, depending on the terms of service, the "shareability" of the work, and other similar factors (Chapter 6).

4. If desired, use reverse image search tools or other techniques to monitor for and identify potentially unauthorized usages of your work (Chapter 7).

 Issue cease-and-desist letters to apparent infringers and/or DMCA takedown notices to online service providers that host apparently infringing copies of your work (Chapter 7).

 Pursue litigation, if desired, against apparent infringers who do not respond to cease-and-desist letters or takedown requests (Chapter 7).

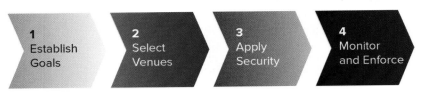

Figure 8.4
The Sharing and Monitoring phase.

The Big Picture

Figure 8.5 shows the complete workflow, in flowchart form.

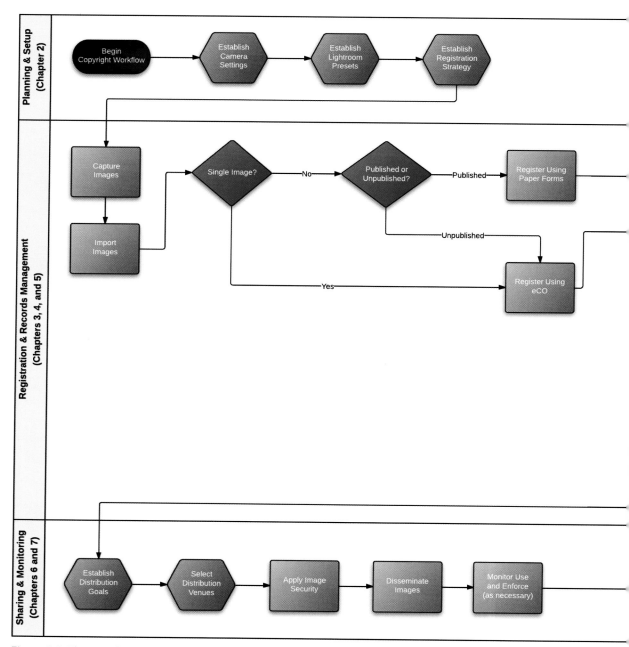

Figure 8.5 The complete workflow

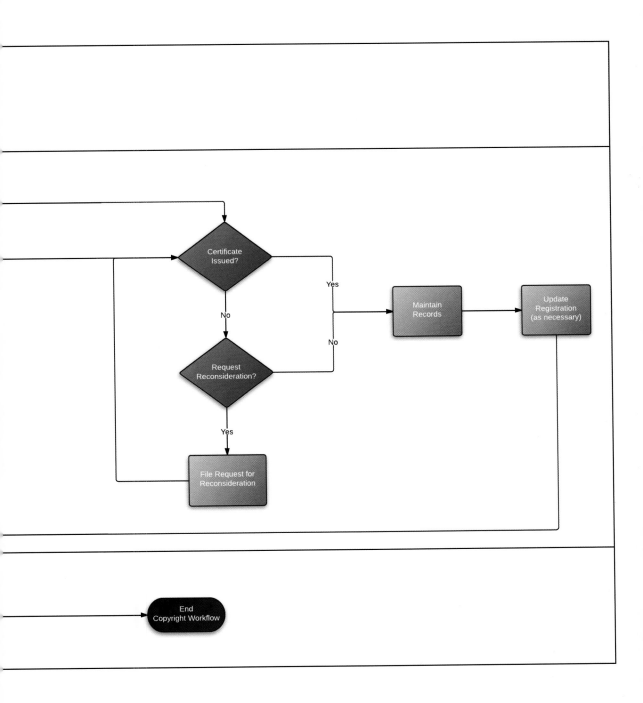

Resources and References

This book covers a significant number of legal and business concepts relating to your work as a photographer, but in many cases, it's only scratched the surface. You can use the resources and references listed in this section to find out more about some of those topics.

APPENDIX A

Resources

For more information about some of the legal, business, and policy concepts discussed throughout this book, consider consulting the following resources, many of which are free.

Books

The business of photography

- *The Art and Business of Photography,* by Susan Carr (Allworth Press, 2011)
- *The ASMP Guide to New Markets in Photography,* edited by Susan Carr (Allworth Press, 2012)
- *ASMP Professional Business Practices in Photography,* 7th Edition, by the American Society of Media Photographers (Allworth Press, 2008)
- *Best Business Practices for Photographers,* 2nd Edition, by John Harrington (Cengage Learning, 2009)
- *More Best Business Practices for Photographers,* by John Harrington (Cengage Learning, 2014)

Copyright and other relevant laws

- *Legal Handbook for Photographers: The Rights and Liabilities of Making Images,* 3rd Edition, by Bert P. Krages (Amherst Media, 2012)
- *Photographer's Legal Guide,* by Carolyn E. Wright (Law Office of Carolyn E. Wright, 2006)

- *The Pocket Legal Companion to Copyright: A User-Friendly Handbook for Protecting and Profiting from Copyrights,* by Lee Wilson (Allworth Press, 2012)
- *The Professional Photographer's Legal Handbook,* by Nancy E. Wolff (Allworth Press, 2007)

Adobe Lightroom and workflow

- *The Adobe Photoshop Lightroom 5 Book: The Complete Guide for Photographers,* by Martin Evening (Adobe Press, 2013)
- *The DAM Book: Digital Asset Management for Photographers,* 2nd Edition, by Peter Krogh (O'Reilly Media, 2009)
- *The DAM Book Guide to Organizing Your Photos with Lightroom 5,* by Peter Krogh (DAM Useful Publishing, 2014), available at www.thedambook.com/organizing-your-photos-with-lightroom-5
- *Lightroom 5 Unmasked,* by Piet Van den Eynde (Craft & Vision, 2013), available at www.craftandvision.com/products/lightroom-5-unmasked

Blogs and Podcasts

Photography and the business of photography

- **Digital Photo Experience (www.dpexperience.com):** A podcast and blog by veteran photographers Rick Sammon and Juan Pons, emphasizing photography technique and business skills.
- **Improve Photography (www.improvephotography.com):** A podcast and blog from photographer and entrepreneur Jim Harmer, primarily covering photographic technique and business skills.
- **Photofocus (www.photofocus.com):** A podcast and blog emphasizing software and photo gear with occasional discussions of business skills and copyright issues.
- **This Week in Photo (www.thisweekinphoto.com):** A podcast about current trends in photography and related businesses, with occasional discussions of copyright and business-related topics.

Copyright and media in general

- **Copyhype (www.copyhype.com):** A blog by Terry Hart, the director of legal policy at the Copyright Alliance. The blog is written for lawyers and policymakers, so it can be a bit technical at times, but it offers a fantastic overview of major copyright policy issues, copyright-related court decisions, and the like.

- **Illusion of More: Dissecting the Digital Utopia (www.illusionof-more.com):** A blog and podcast by artist, writer, and filmmaker David Newhoff that dissects the claims of those who assert that copyright law stifles innovation and harms creativity.

- **On the Media (www.onthemedia.org):** The blog and podcast of the public radio program of the same name, focusing on the media industry and the digital economy, including changing business models in the content industry, with occasional stories on copyright law.

- **Photo Attorney: Serving the Photographer's Legal Needs (www.photoattorney.com):** A blog by noted photographer and lawyer Carolyn E. Wright, who represents photographers on a variety of copyright and business-related matters.

Groups and Associations

- **American Photographic Artists (www.apanational.org):** The APA is an advocacy and educational organization historically focused on advertising photographers.

- **American Society of Media Photographers (www.asmp.org):** The ASMP is an advocacy organization representing the interests of professional photographers and videographers (primarily commercial and editorial) and offering a wide range of educational programming on business and legal issues.

- **American Society of Picture Professionals (www.aspp.org):** The ASPP is primarily an educational organization aimed at the entire visual arts ecosystem, ranging from artists (including photographers) to researchers and buyers to agencies and reps.

- **Copyright Alliance (www.copyrightalliance.org):** The Copyright Alliance is an advocacy organization representing the interests of creators.

- **CreativeFuture (www.creativefuture.org):** CreativeFuture is an advocacy organization representing the interests of creators, primarily in the motion picture field and primarily focused on antipiracy initiatives.

- **National Press Photographers Association (www.nppa.org):** The NPPA is an advocacy and educational organization representing the interests of photojournalists and editorial photographers.

- **PACA Digital Media Licensing Association (www.pacaoffice.org):** PACA is an advocacy organization representing the interests of the visual arts community, but primarily focused on stock agencies.

- **Professional Photographers of America (www.ppa.com):** PPA is an advocacy and educational organization primarily focused on wedding and portrait photographers. PPA is also known for hosting the annual Imaging USA conference and expo.

Online Resources

- **American Society of Media Photographers (www.asmp.org):** ASMP's website offers a wealth of copyright and photography business information, much of which is available free to non-members. The organization also offers frequent webinars and in-person seminars on copyright and business topics that are often open to members and non-members alike.

- **Copyright Alliance (www.copyrightalliance.org):** The website of the Copyright Alliance has a number of great resources for independent creators, including frequently asked questions about copyright, a plain-English guide to DMCA takedown notices, and loads of information on ongoing policy developments that might affect creators. You can also sign up as a grassroots member to stay informed about these issues.

- **dpBestflow (www.dpbestflow.org):** Funded by the National Digital Information Infrastructure and Preservation Program, and managed by the American Society of Media Photographers, dpBestflow is full of free information, guidance, and best practices on all aspects of digital image management and workflow.

- **PhotoShelter (www.photoshelter.com/resources):** Image-hosting company PhotoShelter has dozens of free guides on various topics of interest, including using social media, branding and marketing, pricing, and even copyright (produced jointly by PhotoShelter and the ASMP). The articles are packed with useful information in an easy-to-digest format.

- **U.S. Copyright Office (www.copyright.gov):** The Copyright Office website is a rich source of definitive information about copyright law and policy. If you're looking for more information about copyright registration, check out the Copyright Office's library of circulars and brochures at www.copyright.gov/circs. To keep up-to-date with the office's news and recent policy developments, subscribe to NewsNet, its email newsletter service. You can also sign up to receive alerts about planned downtime due to maintenance of Copyright Office systems. Learn more at www.copyright.gov/newsnet.

APPENDIX B

Statutory and Regulatory References

Many of the concepts discussed throughout this book tie to specific sections of the Copyright Act or regulations of the Copyright Office. To make this book a little easier to read, I kept the text clear of references to those specific sections, but if you're interested in reading the actual statutory or regulatory language, this appendix helps you match up the concept with the law.

U.S. copyright law can be found in Title 17 of the United States Code (www.copyright.gov/title17). The regulations of the Copyright Office are in Title 37 of the Code of Federal Regulations (www.copyright.gov/title37). The charts that follow list the general sections of each of these documents that pertain to the major concepts covered in each chapter.

> **Note**
>
> In some cases, you'll find references to both the code and the regulations for a particular topic, but more commonly it's one or the other. That's because the U.S. Code sets forth the general parameters of copyright law and authorizes the Copyright Office to set up regulations pertaining to its administration of the law, in some cases reaffirming what the law says

Chapter 1 Copyright Basics

Copyright Concept	Title 17, USC Section	Title 37, CFR Section
What copyright protects (and doesn't protect)	102	202.1
Who owns the copyright	201–204	
How long copyright protection lasts	302–305	
The bundle of rights	106, 106A	
Exceptions and limitations, in general	107–122	202.1
Idea versus expression	102	
First sale	109, 202	
Fair use	107	
Copyright registration	408–412	202.1–202.24
Infringement and remedies	501–507	

Chapter 2 Foundations of Copyright Management

Copyright Concept	Title 17, USC Section	Title 37, CFR Section
Copyright notice	401–406	202.2
Published or unpublished	101	
Filing types		202.3
Fees		201.3
Unpublished collections		202.3
Published groups		202.3

Chapter 3 Online Registration Using eCO

Copyright Concept	Title 17, USC Section	Title 37, CFR Section
Registration process, in general	408–412	202.1-202.24 201.3 (fees)

Chapter 4 Registration Using Paper Forms

Copyright Concept	Title 17, USC Section	Title 37, CFR Section
Registration process, in general	408–412	202.1-202.24 201.3 (fees)

Chapter 5 After Applying for Registration

Copyright Concept	Title 17, USC Section	Title 37, CFR Section
Requests for reconsideration		202.5
Recordation of documents	205	201.4
Corrections or amplifications to a registration record	408	201.5

Chapter 7 Monitoring and Enforcement

Copyright Concept	Title 17, USC Section	Title 37, CFR Section
Infringement, in general	501	
DMCA notice and takedown procedure	1201	201.38
Remedies for copyright infringement	502–505	
Statute of limitations	507	

Index

Numbers

500px website, 110
877 phone number, 95

A

address, changing on records, 105
Adobe Lightroom. *See* Lightroom
Aistars, Sandra, 140
American Photographic Artists
 website, 160
American Society of Media
 Photographers website, 160–161
American Society of Picture
 Professionals website, 160
anonymous works, copyright
 duration, 16
applications
 answering questions about,
 92–95
 hearing about, 89
 mailing, 87–88
 tracking, 88
ASMP (American Society of Media
 Photographers), 4
associations and groups, 160–161
attorneys. *See* lawyers

B

batch registration, 35–36. *See also*
 registration
blogs and podcasts, 159–160.
 See also websites
books
 business of photography, 161
 copyright law, 161–162
 laws, 161–162
 Lightroom, 159
 workflow, 159
Boyden, Bruce, 140–141

"bundle of rights"
 distributing copies, 17
 preparing derivatives of
 work, 17
 public display, 17
 public performance, 17
 reproducing work, 17
business of photography
 blogs and podcasts, 159
 books about, 161

C

C&D (cease and desist) letters.
 See also takedown notices
 challenge in sending, 141
 contents, 141
 explained, 141
 legal consultation, 142
 seeing examples, 142
 tone of, 141
cameras, including copyright info
 in, 26
CC (Creative Commons)
 foundation, 129–130
CC Attribution license, 130
CC licenses, 130–131
Certificate of Registration. *See also*
 registration
 filing, 98–99
 keeping, 100
 maintaining, 98–99
 making paper copies, 99
 receiving, 92–93
Chilling Effects Clearinghouse,
 140, 142
claims tribunal, recommendation
 of, 7
*Compendium of Copyright Office
 Practices*, 13
competitions, reading terms of
 service, 128

continuation sheet. *See also*
 Form VA
 completing, 73–75
 descriptions of photographs,
 73, 75
 explained, 73
 first entry, 75
 illustration, 74
 mailing address, 75
 maximum number of images,
 75
 name of author, 73
 name of copyright claimant, 73
 space A, 73
 space B, 73
 space C, 75
copies, prohibiting, 32. *See also*
 deposit copies
Copyhype website, 160
copyright
 basics, 164
 management, 164
 perception problem, 5–6
Copyright Act of 1790, 12
Copyright Alliance, 140, 160–161
copyright blogs and podcasts, 160
copyright claims court, 147
copyright enforcement
 explained, 134
 Titles 17 and 37, 165
copyright info, including in image
 metadata, 26
copyright infringement
 bringing claim for, 21
 as civil matter, 21
 as criminal matter, 21
 identifying, 134
 occurrence, 20
 recovering from, 147
 statutory damages, 21
 suing for, 97–98

Powerful Ideas. Inspired eBooks.

Need a little boost? Then fill up on Fuel! Packed with practical tools and tips that will help you quickly advance your creative skills, these short eBooks get right to the heart of what you need to learn. Every FuelBook comes in three formats—MOBI, ePUB, and an elegantly laid out PDF—so you can choose the reading experience that works best for you on whatever device you choose. Written by top authors and trainers, FuelBooks offer friendly, straightforward instruction and innovative ideas to power your creativity.

For a free sample and more information, visit: fuelbooks.com